NEW YORKERS

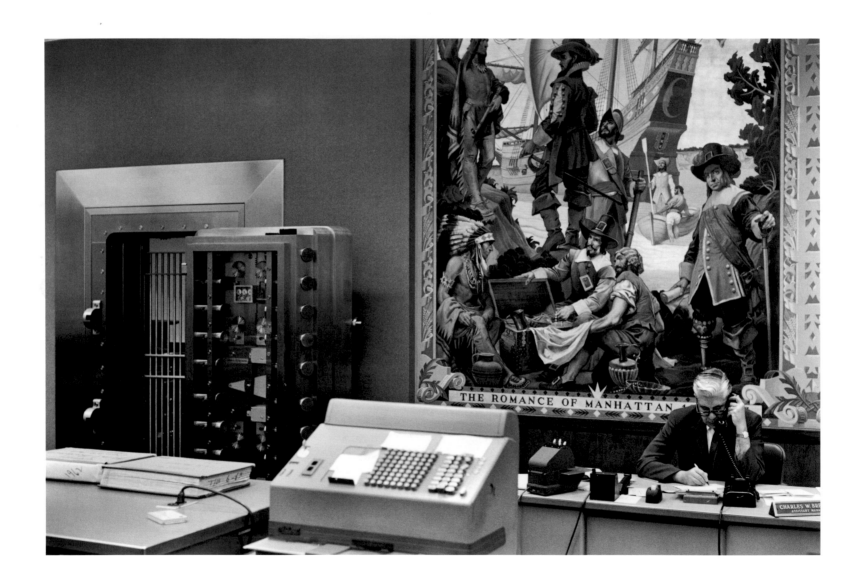

HENRI CARTIER-BRESSON BANK IN JFK INTERNATIONAL AIRPORT, 1967

NEW YORKERS

AS SEEN BY MAGNUM PHOTOGRAPHERS

EDITED BY MAX KOZLOFF

 powerHouse Books New York, NY

NEW YORKERS
BY MAX KOZLOFF

The extraordinary photographs reproduced in this book come from an archive unseen by the public, and are unfamiliar even to many of its private users. Some archives are consulted incessantly, but all are used discontinuously, according to interests that focus only in part on the reserves available. While image banks may be based on institutional or vernacular materials, the one I have looked into here is a media archive, the picture file of Magnum Photos, the photojournalist cooperative often regarded with justice as a lion in its field.

Here is a deposit of visual reportage that covers a long historical span (since the agency's founding in 1947), with a global range of topics, augmented through constantly updated news. These images are supplied from all over the world by indefatigable workers, many of them famous in their own right. Such a stupendous body of photographs comprises a panorama of memories from entire cultures and epochs, often bristling with drama. I went to it with the goal of discovering what it contained on the subject of New York. No one had yet plumbed Magnum photography specifically devoted to life in the Big Apple. The idea seemed promising.

Even were it increased three- or tenfold, the album published in the following pages could only be a small sample chosen from a rich confusion of possibilities. How, then, to make these few pictures count— as a survey of what had been achieved, and as a significant addition to our visual understanding of the city? My first encounter with the file resembled, in fact, the experience of landing in an overwhelming new town, where it was necessary to find one's bearings. True enough, having lived in Manhattan forty-five years, I am conversant with it. But on the hunt for pictures of the metropolis, I needed to be re-acclimated to it all over again. Sights had been arranged by the archive in motley categories loaded with data, yet they gave no hint of an overall shape—and they were, in any event, off my map. Points of attraction and useful features had to be located, relative to each other, across dispersed pictorial territories. A temptation to browse, with a kind of expectant aimlessness, was hard to resist.

This approach led away from the major New York landmarks into the city's more obscure byways and side streets. From their uncentered angles, surprising perspectives revealed themselves, though in a disconcerting tumble. As it turned out, individual photographs came in bewildering formats: slides, miscellaneous work prints, laser copies, negatives, contact sheets, and on a digital file (called E-Cortex) in thumbnail grids. The same must be said for multiform holdings retained by the photographers at home in their personal archives. Furthermore, their *métier* impelled them to be jacks-of-all-trades, competitive practitioners in fields as disparate and yet loosely related as war scenes, social documentary, stories on ethnic enclaves, or political reportage. (New York, of course, is a tapestry of conflicts into which all these narratives are indiscriminately stitched.)

So, it was the waywardness of the image file, not just its size, that challenged the eye. To pasture through this inexhaustible resource was to wander in zones of very mixed intentions, visualized in provisional states. The experience reminds me of a metaphor by the writer D. M. Thomas: "tiny threads of plot that constantly evade recognizable design, as if a carpet weaver had suddenly become color blind."

Picture researchers are opportunists, often on the lookout for telltale patterns they can't predict. If such patterns existed at Magnum, they were necessarily conditioned—in various degrees—by the media services that the pictures were expected to perform. Certain images on contact sheets were marked with red crayon, perhaps singled out for the eyes of art directors from magazines or editorial staffs at newspapers. The line between the pictures such clients might once have considered or chosen and what they had rejected was blurred by the passage of time. Whole sequences of photographs made the case for stories that are faintly remembered or have now slipped into oblivion. Some frothy themes like fashion shows were more fully covered than weighty events like protest rallies. And the photographers themselves frequently intrude into the file by subtracting or replenishing their imagery, for their own good reasons. This potpourri of content gives a lasting impression of being charged with enigmas, impasses, and windfalls, encountered in random order.

It is, of course, a normal impression, familiar to anyone nowadays who surfs Yahoo! or Google. Look for an item, and maybe find a result, amid apparently barren stretches or false leads. But I scrutinized such zones in the Magnum archive because of the intensities they might reveal, not just physical facts that were described. In their fortuitous outtakes from assignments or on their own, the photographers hit their stride. With them, an image can be visualized at a slant to a designated event yet nevertheless be on target. Anyone exploring their collective work must reckon with their tendency to redefine, at a second's notice, what is the actual, as compared with a nominal subject. Atmospherics, moods, or incongruities—and let us not forget attitude—came into play and counted for more than flat exposition. This chronic switching of emphasis and story accent exists as a current that flows through Magnum's files, and keeps them lively.

Sometimes, against odds, the liveliness delivered itself on short notice. Were there any portraits, for example, of Bella Abzug, the feminist and pugnacious anti–Vietnam War congresswoman from New York's Upper West Side, who irked conservative politicians? Magnum actually had an Abzug box, which contained an image of the zaftig campaigner, fluttering in the droll warmth of her entourage (page 154). Here was one of those rare episodes when a direct question received an immediate and clear, if surprising, answer. Still, one would never have found this picture under the heading "Coney Island," where it was taken, or "Richard Kalvar," the photographer. And conversely, there existed no place listing which would have yielded Kalvar's street scene (page 129), the protagonist of which is a man's foot with a dirty sole. New York may be supplied with more feet than usual, but this one foot—or rather, the way it had been framed—was special.

Kalvar's picture spoke to me when I was leafing through pictures with no particular objective in mind. What makes it special has little to do with the cumbersome protocol of even the best search engine. To be sure, no one would even remotely consider his scenario as worth a place on the itinerary of New York's official monuments, such as Rockefeller Center and Wall Street. An album of New York pictures would no doubt be remiss if it excluded them. Still, they represent only the most publicized features of the city, not the uncontainable restlessness of New Yorkers themselves. Kalvar's aggressive vignette of Fourth Street had more abrupt energy than many a routine picture of the tallest macho towers. I did not look so much for the photographers' acknowledgement of a mighty skyline as for a sense they gave of having breathed the combustible air of the place.

Needless to say, the "air" in question is dense with social life. This sociality characterizes the material objects that people handle in their work or ordinary business. Such things are shaped, scuffed, or worn down through rough use. A fire escape in Chinatown, the Fulton Fish Market, the dashboard of a police car at night, a water-spurting hydrant in Brooklyn, front stoops, jammed subways defaced by graffiti, someone's lost gloves in a puddle, smeared glasses in bars: all these speak of the exhilarating hassle that is New York experience.

Such experience leaves its mark more dramatically on faces that have been weathered or textured by their history. The perception of the moment is not just a glimpse into the unanchored now, but of an aggregate of memories and passages that have seasoned urban life. I like pictures that drive home the idea of the metropolitan setting and of behavior in the street as embroiled by each other—in an idiosyncratic dialogue. A high number of such images describe situations that may have story content, at least in embryo. But many others depict populated scenes, with citizens on errands, as vagrant phenomena. These photographs configure palpable and even earthy situations, yet they're elusive in meaning. They purvey fleeting hints of social connection or disconnection, manifested only through a photographer's impulsive visual reflexes. Such is the scene in Alex Webb's panoramic shot of a woman who may be in minor distress, or even on the verge of panic (page 59). The camera intrudes into a flux of pedestrian motives, catching implications or echoes of them, some humdrum enough, but others charged with inexplicable portents.

On the official visit of Khrushchev to New York in 1959, during a Cold War crisis, Burt Glinn was alerted to the fact that a skywriter had traced an ominous though fading cross in the heavens above Rockefeller Center, while passersby in the foreground seem oblivious (page 54). The Kalvar photograph, too, divides its attention, the better to offer a mystery. An alarmingly oversized bare foot on a stretcher (pictured at a wide angle and close in) is juxtaposed with a woman eating a popsicle and a man strumming a guitar (while also playing a harmonica, for good measure). There can be no emotional resolution in the discordant sight of two self-absorbed people enjoying themselves alongside a sick or injured victim, whom they ignore. But, far from being didactic or moralistic, the tone of the photograph is poetic. Each of these three individuals is in a separate space, but there exists a fourth position, that of the observer with a camera, responsive in a flash to the pathos of the whole.

Richard Kalvar did not invent that whole, nor did he quite observe it, either. The sorrowful effect of his field would not have registered and perhaps did not exist, except to an eye attuned to those little flickers of disassociation that radiate along New York streets. One might look at the city itself, they seem to say, just as one could consider such picturing of it, as a spontaneous collage of pleasures— and of grief.

"This is really a great city," remarks Woody Allen to Diane Keaton, in *Manhattan*, 1979; "I don't care what anybody says." Allen's native pride is humorous, and a little ironic because he makes it sound intrepid. So much in the Magnum file is like this, too: a praise of the city that takes defensive measures in the expectation of being doubted. Nevertheless, part of the doubt may be encouraged by ambiguities that photographers knowingly exploit. Leonard Freed's picture of the 50th Anniversary celebration of V-J Day in Times Square (page 93) is an understandably festive image that provides an emotional double-take. In the background are two billboard-sized reproductions of Alfred Eisenstaedt's iconic photograph of a sailor amorously overwhelming a nurse, taken near that same spot at Times Square a half-century before. In the foreground are actors, rehearsing the behavior of Eisenstaedt's "couple." Freed's shot operates on two levels: as a comparison of a prodigious historical moment with an ordinary one, and of a documentary image with his photo-op. The past event was uniquely glorious and exuberant; the present one, meant to chime with it, is studied and artificial. Leonard Freed closes with the actors, as did his predecessor, but he's also aligned with and includes his fellow photographers—spectators, not celebrants—at this staged scene. So, he achieves a consciously dissonant act of witness—a picture immersed in, yet also detached from, public memory and media, by a media person himself.

For all its ambivalence, this bouncy but strangely joyless picture does allow for a view of New York as a great city. After all, had Manhattan lacked greatness of stature, it would not have been worth deflating a little. New York is blazoned with obtrusive media images that either evoke the city's myth or indirectly affirm its power as a capital of communications. Magnum photographers certainly testify to this—while additionally contributing their part to its irresistible state of visual affairs. The consumer's paradise of Manhattan is as beguiling a subject for the camera as luminous nature was for Impressionist painting.

Whether affectionate or absurdist, these observers take a playful look at our lurid media scape. Eve Arnold shows a worker who resembles an ant, crawling high up a gigantic, glowing "N" (on a "Bond Apparel for Women" sign); to his right, a plaster goddess smiles, her chiton outlined in neon (page 12). Years later, Nikos Economopoulos depicts a stretch limo crowned by a billboard of Lucille Ball and Desi Arnaz, lips puckered for a silly kiss (page 35). As a platform of signs, New York can't help enacting its own spectacle—a Luna Park satirized here as a misalliance of glamorous emblems, each lording over the next. For all that, the photographers are susceptible to the aura of hype, even as they may chide its pretenses.

Certainly they enjoy the presence of movie stars, who promise photogenic dividends. A whole book, *Magnum Cinema: Photographs From 50 Years of Movie-Making*, reveals the durable affinity these photojournalists have with the film industry. In a Burt Glinn double portrait, one of the founders of Magnum, David Seymour (known as Chim), does not hesitate to rub shoulders with Marilyn Monroe (page 155). The owlish photographer and the lush comedienne make a humorous pair, in line with the Magnum tendency to play two or more disparate presences against each other in one view. You can see it in a posed outdoor fashion shot by Ferdinando Scianna, where a gorgeous model and an old lady ingeniously smile at each other (page 23). And Bruce Gilden lifts this motif of comparison to a new height, when he catches two nearby gentlemen, a short white man and a tall black one, guarding their tonsorial splendor with a sniffish *hauteur* that is hilarious (page 36).

The comedy of manners that runs through these images is dependent upon their binary structure. It illustrates a kind of visual Ping-Pong that sports with social differences, opposite life stages, and class identities. "What is aura?" asked Walter Benjamin, "—a strange fabrication of space and time: A unique apparition of a distance, as near as it might be." When looking at these pictures, with Benjamin's cryptic "aura" in mind, one can almost detect an impression of distance in tight physical circumstances. Even when they're in close contact, figures are nevertheless separated from each other, as if they existed in two different spaces. One of them might be called

starry, the other, worldly—and the view of both is profane. Take as an example, Bruce Davidson's glimpse of a rabbinical type, who literally answers to a higher authority, about to walk by a barebacked blond, his beard and her braids equally decorative (page 57). The life of the city is profuse in its offering of such unlikely meetings, where those who glow with an almost sacred aura vie with more everyday creatures on an equal footing.

Dennis Stock reflects on a kindred scenario, to curious effect (page 122). A passerby looks into a furniture store window and may or may not glimpse, among the wares displayed there, a seated, dour young man gazing back. This person, half lost in shadow, was just then making a name for himself—Jimmy Dean. Stock had been doing a story on Dean for *Life* magazine. To New York, and more particularly the Actors Studio, Dean owed his training in the "Method" style. Following this celebrity as he walked the streets, the photographer posed him as a kind of still life, an animate article that could be bought. Of course, the more the image appears to demean the legendary qualities of its subject, the more it relies on them to achieve its ambiguous result. Dennis Stock told me that he wanted to portray the actor on that larger stage which is the city itself. If so, New York is here regarded as a setting of exhibits with viewers, each in an undecided—yet clearly artificial—relation to the other.

Photographers fall into the category of viewers, restricted to the description of bits and pieces. I was reminded of that fact when I considered Henri Cartier-Bresson's image (page 48), which features a carved wooden rooster, a teleprompter roll, and ornate slot machines in an indeterminate space inhabited by three statuesque men, one with earphones. We're so accustomed to public views of New York that this backstage scene takes us unprepared. Such a tableau vivant makes no sense, unless we accept it for what it is: a collection of unassorted objects for show—props, merely—amidst workers who could almost belong to the same class of things. Here is a group of objects lying about, prior to assembly for one or more productions in a television studio. They have yet to assume their role in a story, yet this preliminary state tells its own story—of how spectacles are constructed for public media consumption.

Clearly, these photographers do not perform as ordinary consumer/spectators. Like Cartier-Bresson, here they're often drawn to unpresentable or discommoded aspects of the social environment, respecting their weight as constituents of daily life. In their personal work, a realist aesthetic takes issue with the buoyant world of automatic promotion and idealized forms contrived by Madison Avenue. What is being celebrated and what there is to celebrate are not the same things, and the photographers imply the distinction. The landscape of hucksterism appeals to desires that are apparently beyond history—and is all the more, therefore, a target for the skepticism of those who are documenters of history, by inclination and by trade. Were they discursive rather than figurative artists, their work would be rumorous with scraps simultaneously overheard from mismatched scripts. New York, after all, is an unimaginably gregarious city. With photography, the wordplay is silent, creating a pantomime effect of public and private messages, in tension with each other.

How did this photographic form evolve? The kind of sophistication I am describing did not spontaneously beget itself; it came from places. To say that Magnum's perspective on New York developed from international street genres would not exactly be a discovery, since Henri Cartier-Bresson, the agency's last surviving founder, presides over them all. To say that Magnum owes a debt to the serious photography long based in the city sounds reasonable, but the relation between them seems more an interplay with mutual themes than a genealogical bond.

Just the same, individual pictures do occasionally suggest a sibling resemblance. Eugene Richards' derelict, crawling out of the subway grate (page 80), might remind a viewer of the squalid citizens in Jacob Riis' Mulberry Bend. Where have we seen as scalding a caricatural style as Bruce Gilden's (page 163), if not in his great predecessors, Lisette Model and Leon Levenstein? Eli Reed (page 115) had certainly grown up with a knowledge of Aaron Siskind's Harlem Project. Bruce Davidson (page 87) and Susan Meiselas (page 79) could hardly have been ignorant of Helen Levitt's work with children. There are moments in the career of Eve Arnold that recall Roy DeCarava's (page 45). Leonard Freed's gritty Stock Exchange (page 101) and William Klein's acid New York have a lot in common. And now we know that Burt Glinn cruised Sammy's Bowery Follies (page 44), and Eve Arnold shot Mrs. Cavanaugh (page 152), the dowager at the Metropolitan Opera, as Weegee did (but with more empathy).

Ricochets of this sort must be inevitable, given the allure of the common subject and the proximity of the workers. Their rapport is evident enough, yet we can also detect interesting seams within it. One runs along the line "visitor-native," a distinction that holds despite the mixed origins of the many concerned. From France, the United Kingdom, Italy, and Asia, Magnum photographers have campaigned in New York as incisively, if on briefer terms, as the locals. Foreigners, though, are more apt to appreciate the city as the site of piquant rituals, charming caprices, or vaguely sinister practices. Take a look at Raymond Depardon's unsavory character (page 28), or Inge Morath's family group, out for a stroll with pygmy cow and llama (page 168). Martin Parr takes acerbic note of a small American flag strung up with kielbasa sausages by a patriotic butcher (page 62). Abbas snaps a Christ-like figure on Broadway (page 55). In such imagery, New York comes across as the turf of implausible foibles and outlandish folkways.

With those based in the city itself, on the contrary, the setting is rarely taken to be somewhere else. Instead of looking at it from the perspective of an amused anthropologist, they ingest New York with a territorial incredulity. For New Yorkers at least, certain short-fused pictures by Bruce Davidson or Elliott Erwitt seem to have gotten the colloquial hang of things quite right. The pictorial approach even assumes a certain complicity with its audience, a crystallization of unique incidents shared with viewers aware of their overall pattern. One can speak of a kind of cultural shorthand at work in Erwitt's marvelous picture of two men scuffling, where it seems that a conversation—we hardly need to know its gist—has taken a bad turn (page 64). Davidson, who in the 1950s would pivot on a dime, also internalizes such rough appraisal, as if it were normal discourse. As background, the city exists pretty much as a shambles, but a poetic shambles. An indigenous lyricism wells up within abrasive surfaces, and it does wonders with the palpable fatigue and fortitude of New

Yorkers. Some photographers from abroad are also attuned to this atmosphere: Ferdinando Scianna, for example, at the subway, filled with weary people (page 112), and the Parisian Richard Kalvar, as we've seen (but then, too, Kalvar is a transplanted American).

It will not do to push this "visitor/native" dichotomy too far, since the Magnum photographers are, on the whole, cosmopolitans, marked by their peripatetic experience. It has given them a backlog of harsh impressions across the world, which make their account of contentious New York look gentle by comparison. Eugene Richards, who unhesitatingly plunges into dangerous scenes, had to overcome his timidity when photographing a family that was just having a good time (page 71)! But such mildness also contrasts with the ferocity of New York photographers who have treated the same themes of loneliness, crowds, and the life of minorities with an urban voyeurism that is more ingrained. When Robert Frank, Garry Winogrand, Louis Faurer, Diane Arbus, and Saul Leiter roamed the city, in the 1950s and 60s, they took its measure with a kind of predatory estrangement. They had made an intermittent living within commercial markets, which enlisted their craft, but not their hearts and souls. The difference between the glossy work they were obliged to do for hire, particularly fashion, and the much freer, seemingly unprocessed vision they evolved on the streets was so emphatic as to form a chasm in their professional lives. Some of them practiced their art with desperation, as escapees from an irrelevant, or worse, an onerous and repressive system. At Magnum, in contrast, the members identify their calling as photojournalism, from which they depart at unscheduled moments into personal observation. Overall, I think this polarity of motives, with its opposing gravitational fields, charges the repertoire of New York photography with a characteristic excitement.

A photojournalist is occupationally predisposed to consider a basic pictorial unit, a "story," to be illustrated by a shrewd cluster of related images. Each of them is nominally intended to bridge with others in a joint future collaboration with text. The outcome would be a feature designed for a readership with a niche interest within a journalistic context. Certainly, a resonance of that context is felt in Hiroji Kubota's picture of a schoolroom for emotionally disturbed children in Brooklyn (page 67). An alternating series of front and back views of the seated students, posing uncertainly for their portrait, compartmentalizes their space in a way that hints of their illness. The effect is all the more poignant because it is matter of fact. I must also note that Kubota, acting here as a member of the press, has taken us into a place rarely seen in the annals of purely artistic street photography.

Documentary photography often fulfills itself through access into obscure, disregarded, or off-limit scenes. In them, after all, a potential for high informational content is apt to provide what journalists call a scoop. An enterprising project of this sort, brought off with an illustrative panache that verges on expressionism, is Susan Meiselas' study of a New York S & M parlor—not your usual subject. In the book introducing us to the full color and undomesticated splendors of this establishment, *Pandora's Box*, she writes: "Into Pandora's mind, Zeus put insatiable curiosity, and then gave her a sealed box that he forbid her to open. One day, she opened the lid, and out flew all the miseries, sufferings, and evils that still plague humanity to this day." If Meiselas had intended to remind us of the similarity between journalistic professionalism and Pandoran curiosity, she calculated well.

I selected from her book for inclusion in this compilation a strange picture (page 21). In the foreground of an eerily blue interior, a masked maid appears to be dusting(!) a huge bouquet placed on an antique wooden pedestal, while at the back, a door, slightly ajar, emits a cobalt light from beyond. The figure has broad shoulders, is dressed in shiny black leather, and displays hairy male legs with feet outfitted in high heels. Only after I had reacted to this scene's smarmy allusion to fragrance and cruelty did I realize how intelligently it visualized themes taken up by other Magnum photographers—the accent on human beings as part of an exhibit; the layered interchange between absence and presence; a taste for make-believe that is exposed or exposes itself; a self-reflexive pictorial program which flirts with emotional discord. For that matter, hadn't Richard Kalvar joked with these very motifs and devices in his picture of an aboriginal delicatessen sign: "HOT & COLD [H]EROS" (page 26)?

Because it was self-assigned, as were many Magnum stories, Meiselas' project, however journalistic in origin, is anomalous within the profession. This reporter, who took it upon herself to cover the Sandinistas' revolution in Nicaragua and the visual memory of the Kurds in Iraq, did a photo-essay on Santa Clauses in a New York mission center (page 107)—a speculative work rejected by magazine editors who wanted more upbeat treatment. From this episode, and countless related stories her colleagues could tell, it would be fair to conclude that Magnum photographers often operate ahead, or to the side of media norms, and without mandate.

A documentary ethos nevertheless shines through even their most independent work. Eugene Richards' *Cocaine Blue/Cocaine True*, and Bruce Davidson's *East 100th Street* come to mind. The first was a harrowing study of drug addicts, mostly in Brooklyn, the second, of black life in "the worst block of the city." Davidson's magnificent book is such classic New York reportage of difficult lives (page 132), that it traces right back to Lewis Hine's social reformist imagery of the early 20th century. But by the time Davidson completed it in the late 1960s, the activist tendencies of what has been called "The New York School" had long ago petered away. Hine's principled concern oversaw the development of Walker Evans' and Ben Shahn's Depression-era photography onto the bitter solicitude of Morris Engel and Aaron Siskind of the Photo League. Thereafter, Weegee, during the 1940s, broke the spine of their legacy with his humorous operatics of misfortune, to be followed by an ever more sardonic fascination with misfits and cult styles, represented, say, by Lisette Model, Diane Arbus, Larry Fink, and Nan Goldin. The still-humanist consciousness of Magnum imagery, though at times compatible with this darker vision, must be considered out of phase with it.

There is a further point to be made about such divergence—the productive failure of the one sensibility to mesh with the other. From the 1950s, New York photography rejected mainstream liberalism along a trajectory that we can also recognize in some literature, film, and cultural studies. Eventually, this strain culminated in a denaturing critique of the media themselves and the virtual demise of the street genre, now replaced by constructed photographic tableaux in art galleries. Viewers of photography—so goes the argument—are consumers of fiction, a visual artifice all the more expanded with the advent of our postmodern age of digital manipulation.

By contrast, the various acts of witness we see in these pages have no such intelligible and coordinated history. Their individualism is based on intuitive responses that alter from scene to scene. If they have any conceptual framework, it can only be the loose anticipation of narrative. Insofar as story content is worldly, it is ripe with material exposition of a past that is datable. The same must be said for photojournalist techniques that have stayed in the thrall of Cartier-Bresson since the 1930s. They have remained fairly steady, in order to let an incontinent reality take them where it will. When that reality happened to be 9/11 (pages 75 and 133), who would complain that photographic testimony of it was not fashionable?

Myself, I think that the act of witness may be powerful even when it does not treat of events that cause grief or shock. The sheer radiance of the everyday, when perceived by eyes as sharp and with minds as witty as those gathered here, is enough of a turn-on. Like the photographers when they prowled the streets, I found it helpful to adopt a kind of passive vigilance as I scoured their files. Since it lacks a middle and an end, the gathering is necessarily sequenced as an anthology, profuse with fortuitous insights. These have been arranged as a set of "movements," featuring themes and variations, with a sense, almost, of a music they convey. Rather than listening to each other, they answered—with virtuoso curiosity—only to what was before their eyes.

In the end, this book has no reason for being, other than to inform, startle, and delight those who have regard for New York. The "history" opened up here is so unsettled that it is no linear history at all—just a patchwork of sensations, afforded by pictures unseen for too long, and now conducive to readings. But then, is history itself anything but a chronicle that is endlessly reshuffled? The French historian Lucien Febvre has written: "All history is a choice. It is so by the very fact that chance had here destroyed and there preserved vestiges of the past. It is so by the fact that, in the abundance of documents, man shortens, simplifies, accentuates, or obliterates."

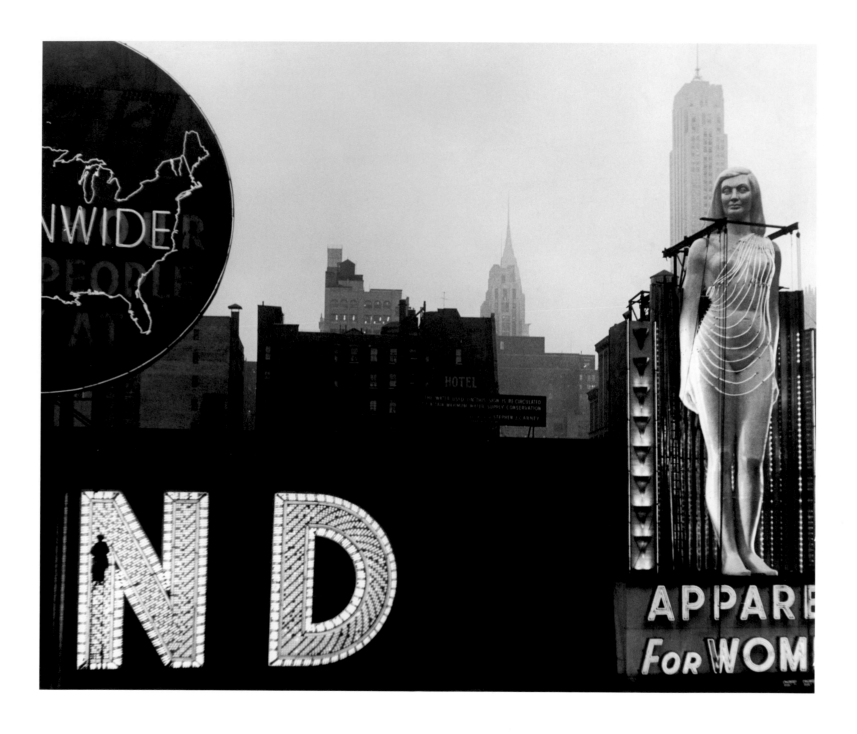

∧ **EVE ARNOLD** TIMES SQUARE, 1995 > **BRUCE DAVIDSON** ROOF TOP ON EAST 100TH STREET, 1966

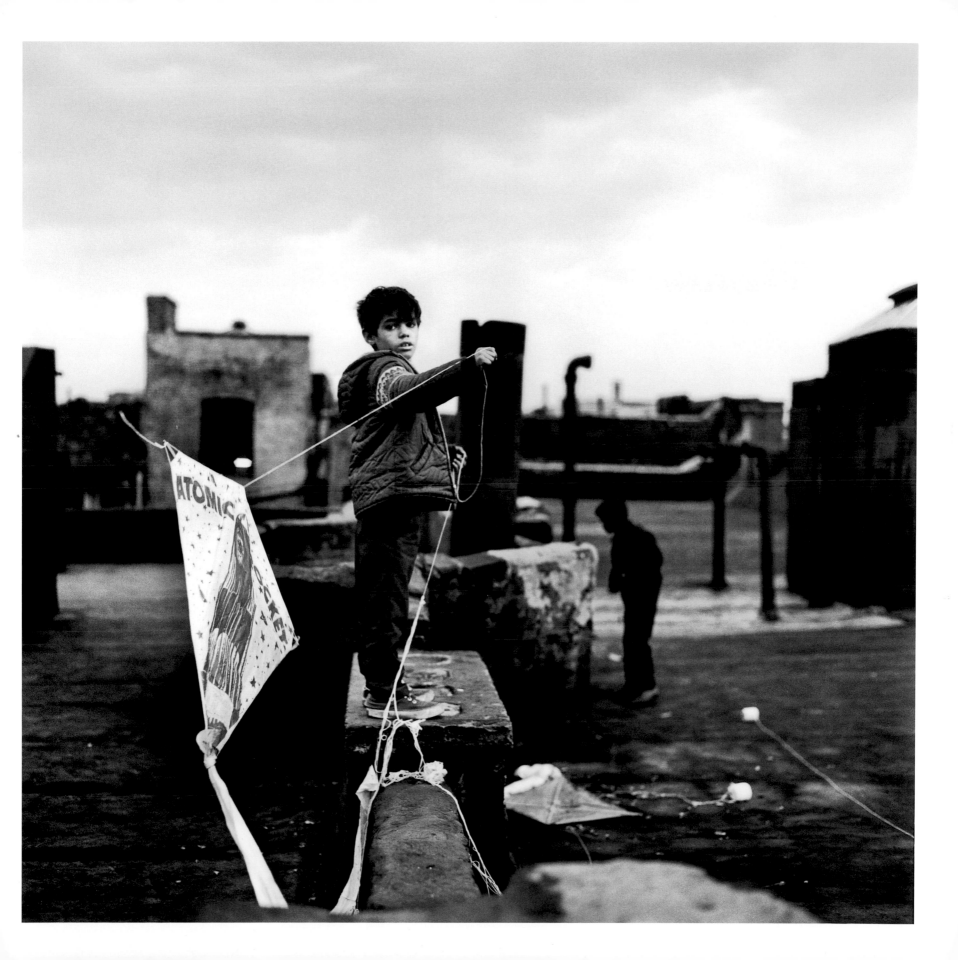

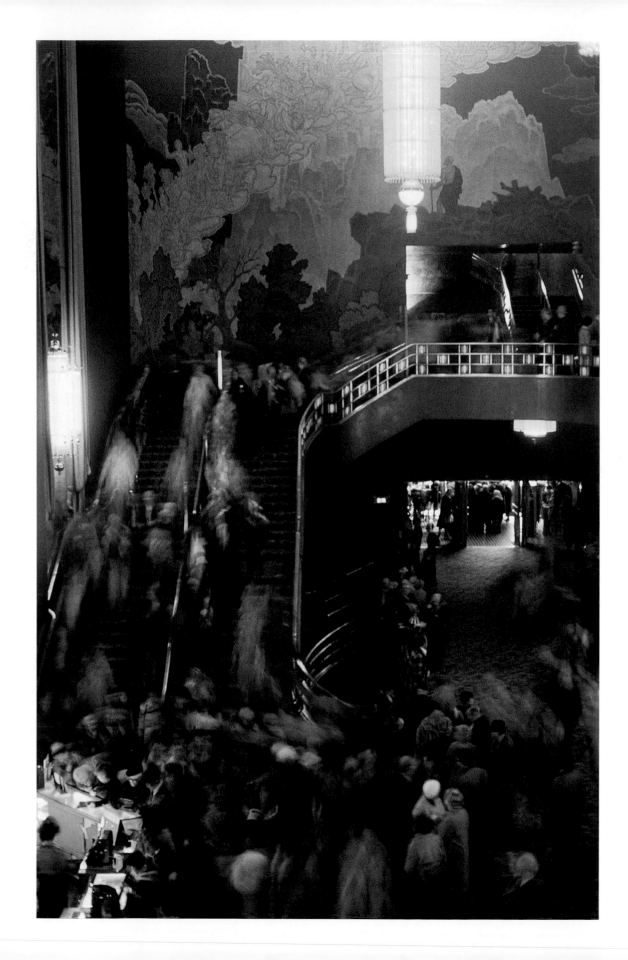

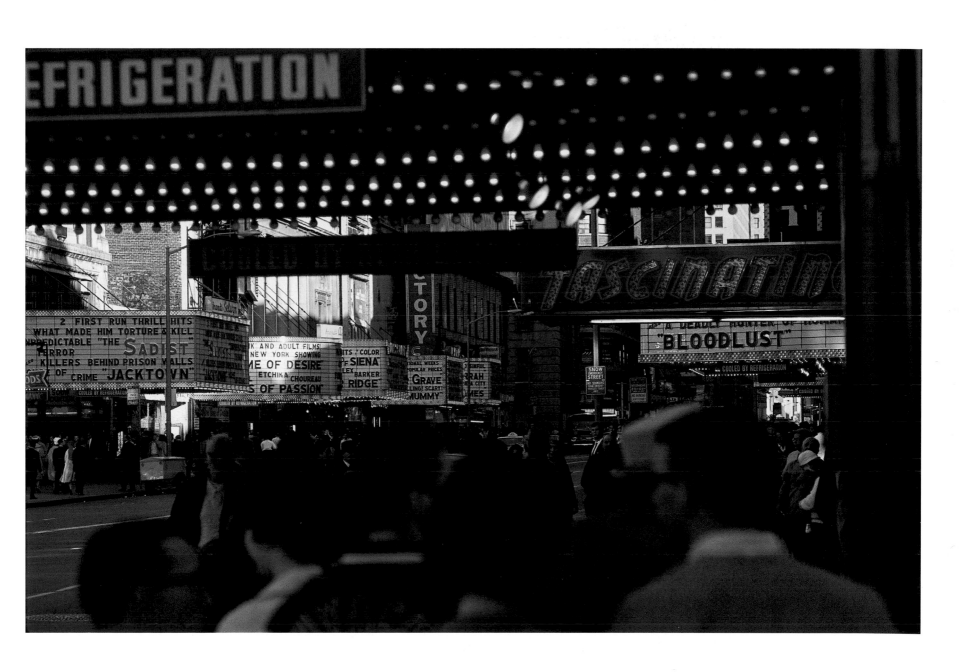

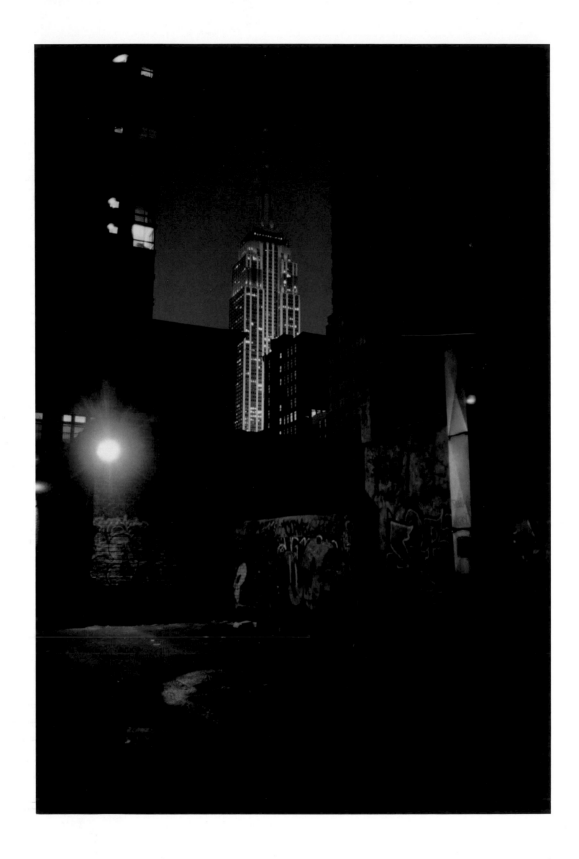

∧ **CHRIS STEELE-PERKINS** VIEW OF EMPIRE STATE BUILDING, 2001 > **GEORGE RODGER** VIEW FROM EMPIRE STATE BUILDING OBSERVATION BALCONY, 1950

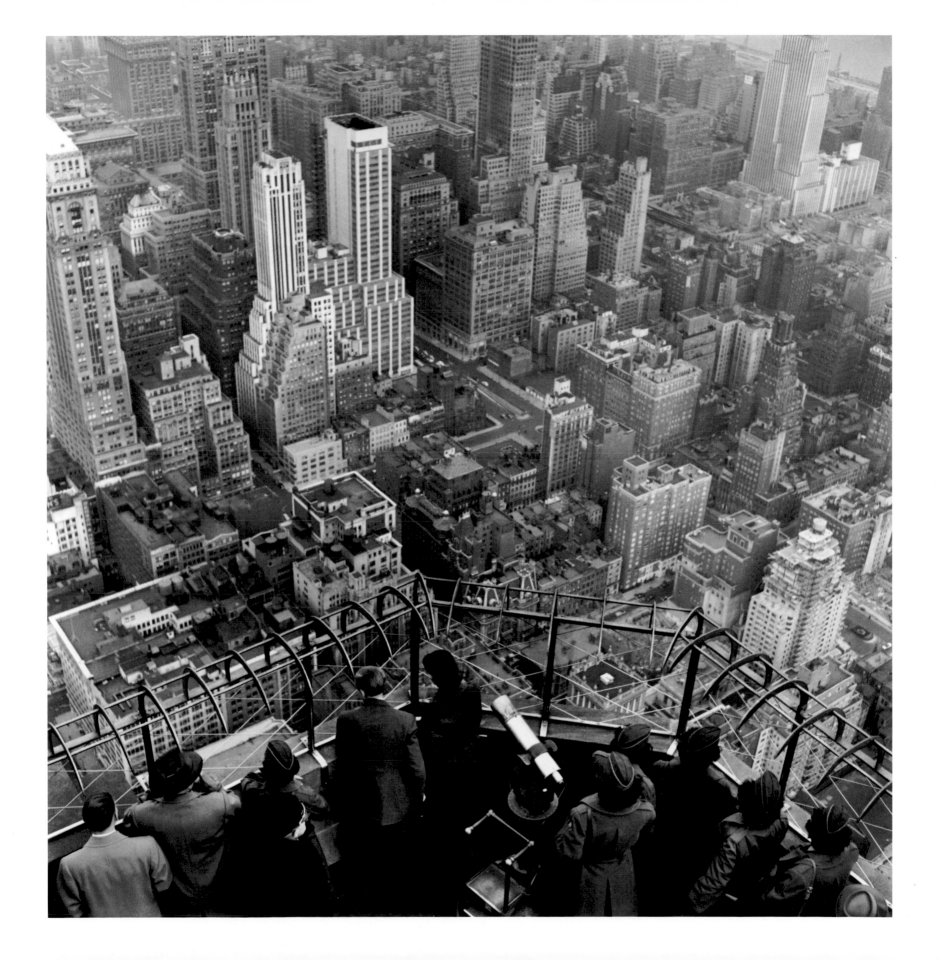

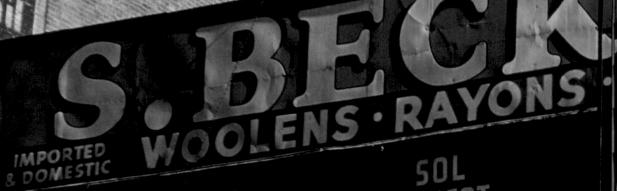

S. BECKEN[S]

IMPORTED & DOMESTIC · WOOLENS · RAYONS · SILKS =

SOL MOSCOT

EYES EXAMINED
BY REGISTERED OPTOMETRISTS

SPECIALIZING IN THE FITTING
OF GOOD MODERN EYE GLASSES

11[8] 118

SOL MOSCOT
OPTICIAN

For the Famous FOR OUR **PROMPT SERVICE**
MODERN EYEWEAR
GUARANTEED WORK

118

Established 1920

SOL MOSCOT
OPTICIAN
·
Complete **GLASSES & REPAIRS**
MADE WHILE YOU WAIT

**ALL WORK DONE BY
SKILLED LENS GRINDERS**

118

SOL MOSCOT
118

GLASSES

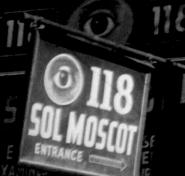

⊙ **118
SOL MOSCOT**
ENTRANCE →

113 ENTRANCE

SOLMOSCOT
ENT

**CRAVATS
BELTS**

VICTOR'S 118

**WALL[S]
JEWE[L]**

118 TIES · VICTOR'S · BELTS

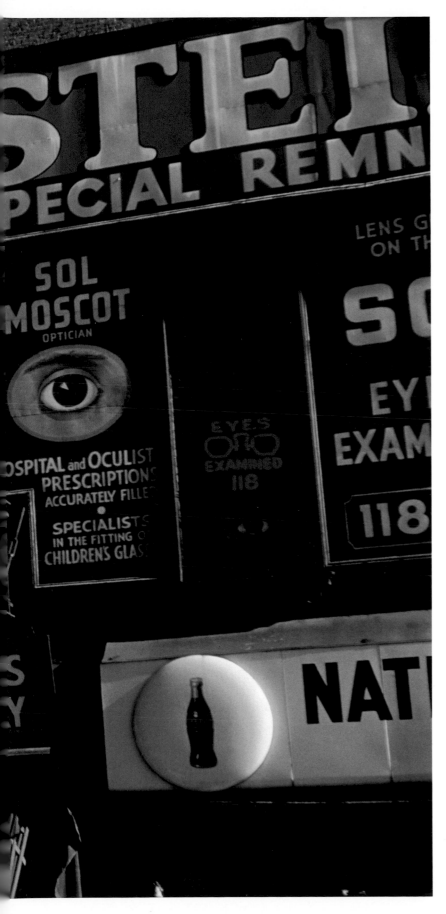

EROS—HOT & COLD

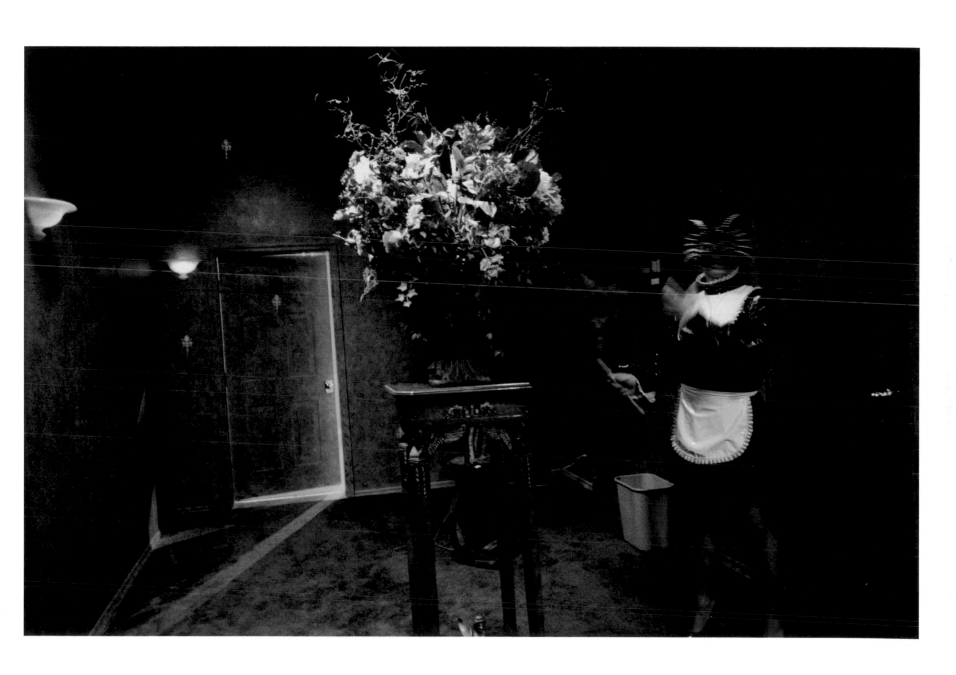

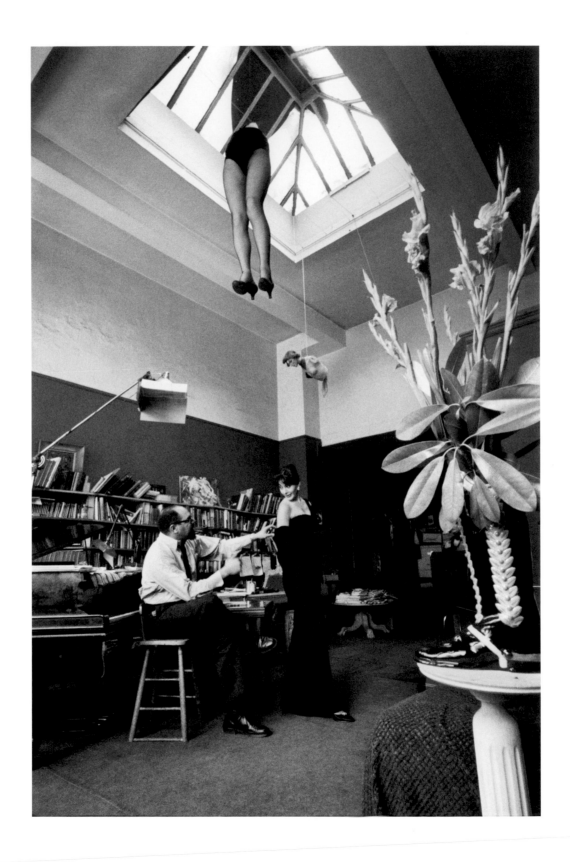

DENNIS STOCK CARNEGIE HALL STUDIOS ON 57TH STREET, 1958

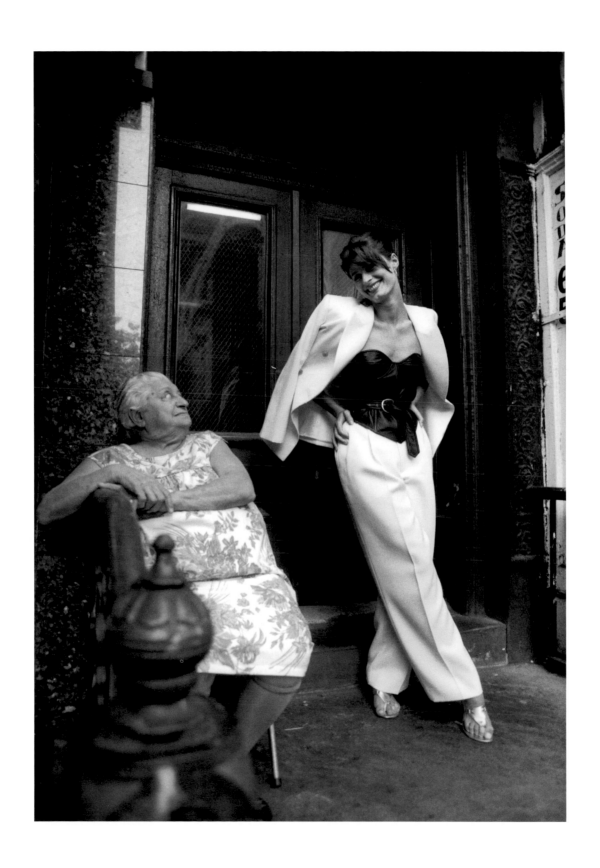

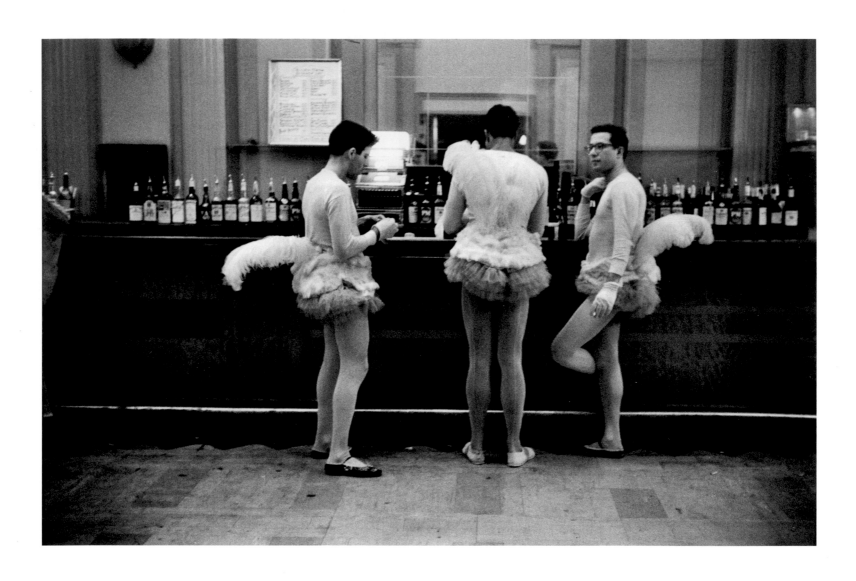

ELLIOTT ERWITT MEN IN COSTUME AT A BAR NEAR CARNEGIE HALL, 1956 > **BURT GLINN** SAMMY'S BOWERY FOLLIES, 1949

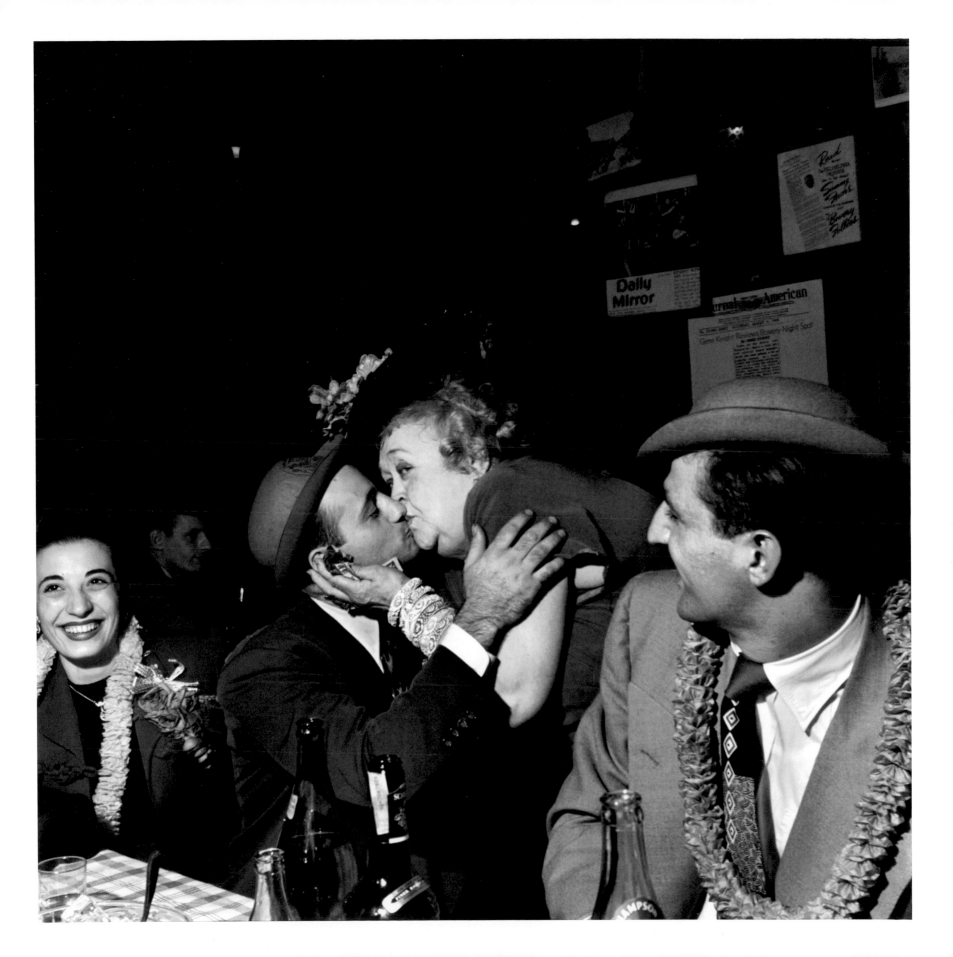

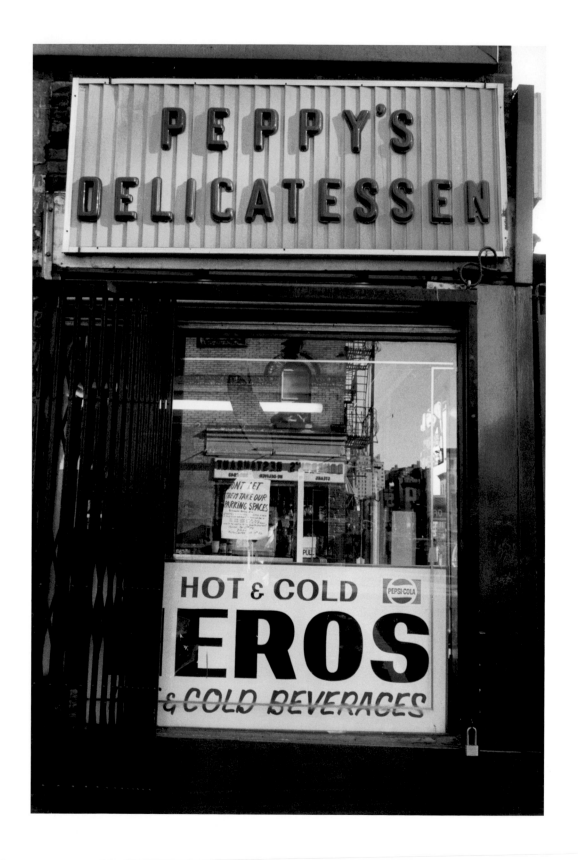

∧ **RICHARD KALVAR** PEPPY'S DELICATESSEN ON THE LOWER EAST SIDE, 1978 ＞ **BURT GLINN** STRIPPER AT CLUB SAMOA ON 52ND STREET, 1949

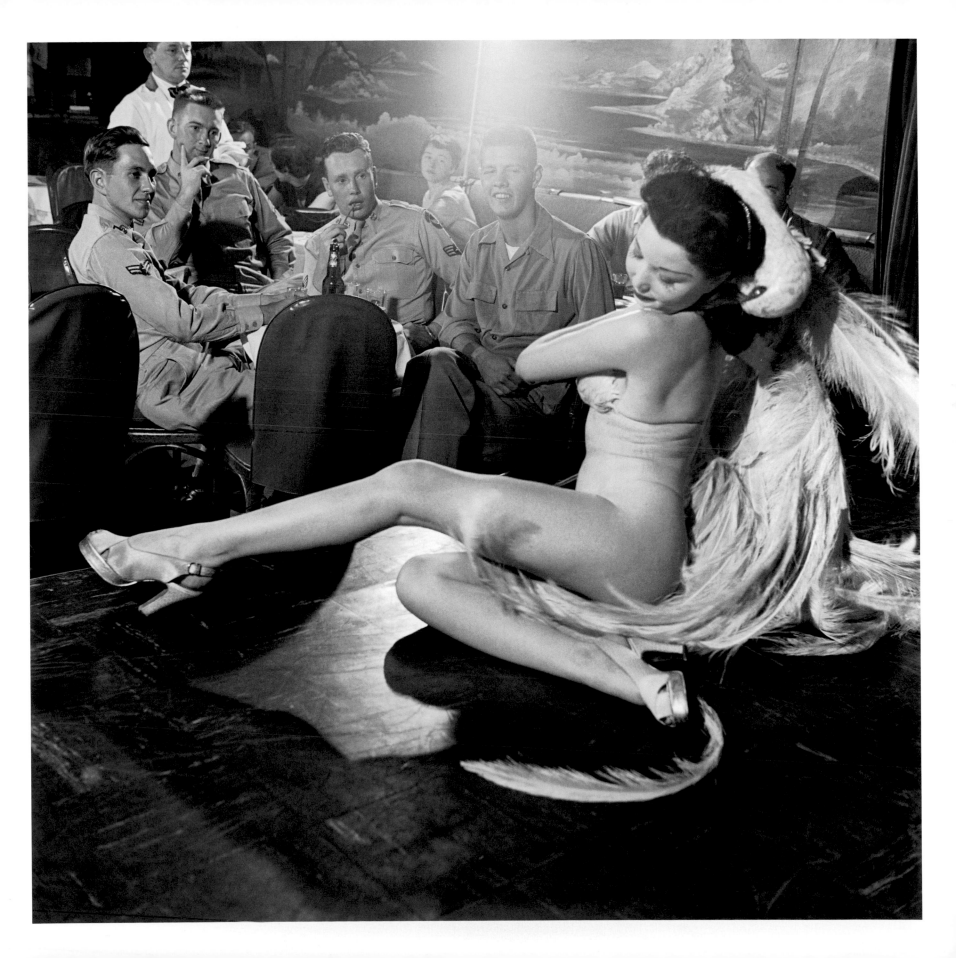

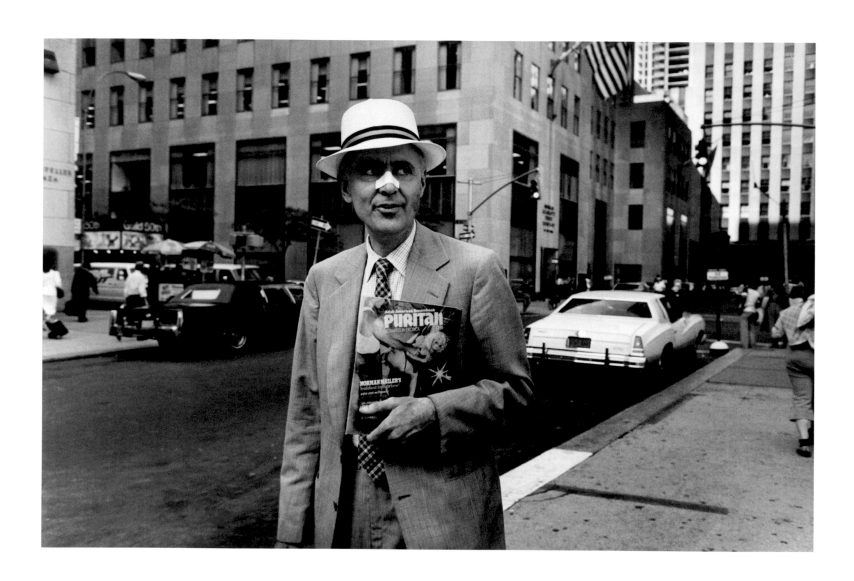

RAYMOND DEPARDON NEAR ROCKEFELLER CENTER, 1985

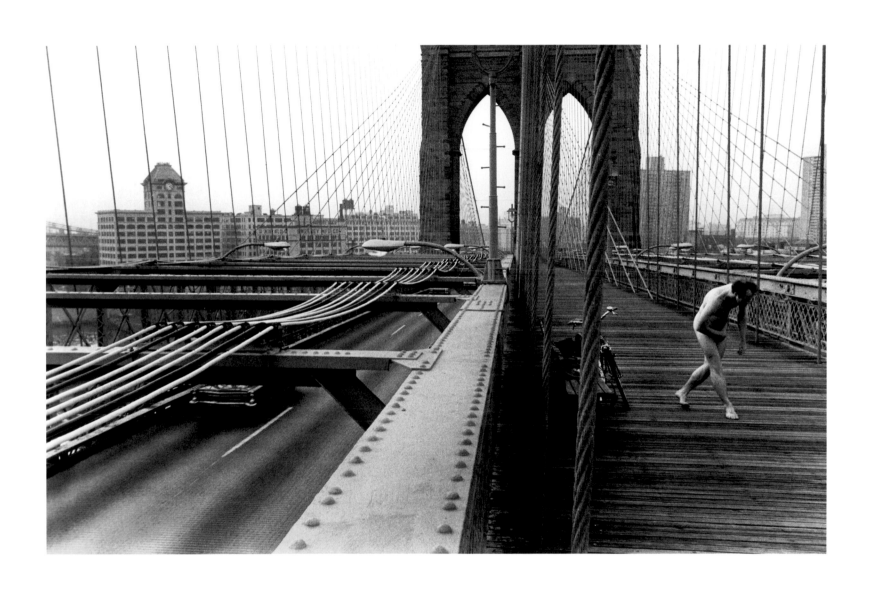

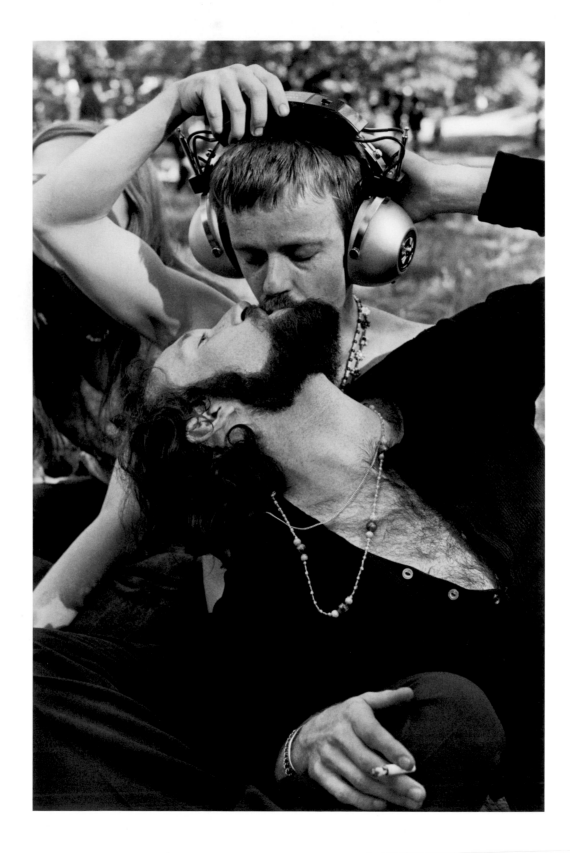

∧ LEONARD FREED GAY COUPLE KISSING IN CENTRAL PARK, 1968 **> BRUCE DAVIDSON** THE GARDEN CAFETERIA ON THE LOWER EAST SIDE, 1973

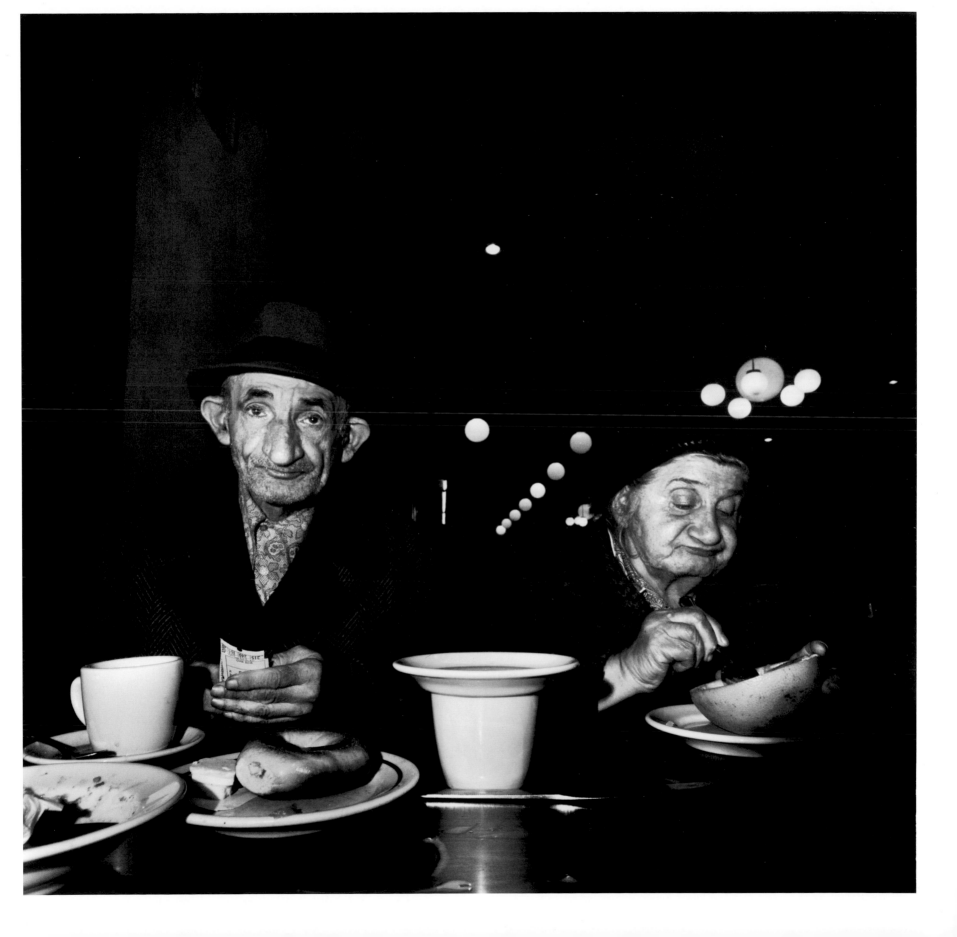

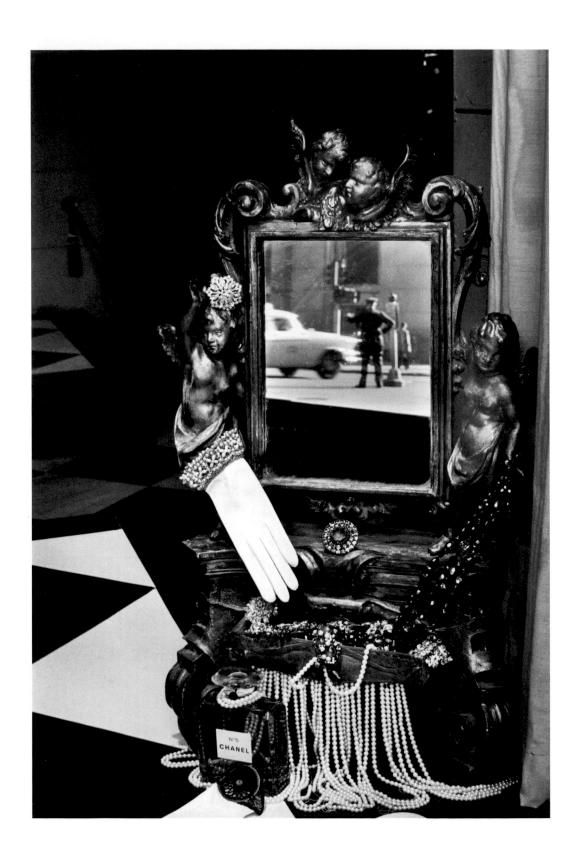

COSTA MANOS WINDOW DISPLAY ON FIFTH AVENUE, 1961

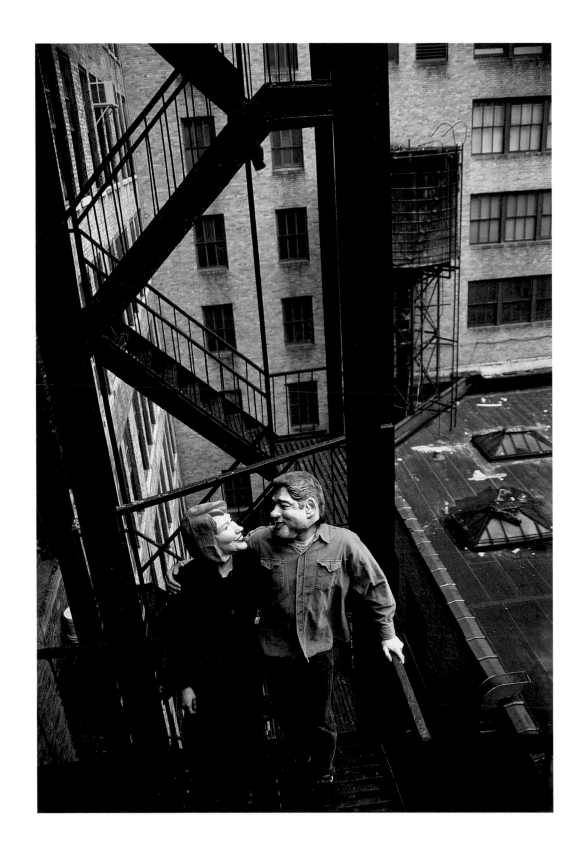

INGE MORATH HILLARY AND BILL CLINTON MASKS FOR HALLOWEEN ON A FIRE ESCAPE IN THE FLAT IRON DISTRICT, 1997 33

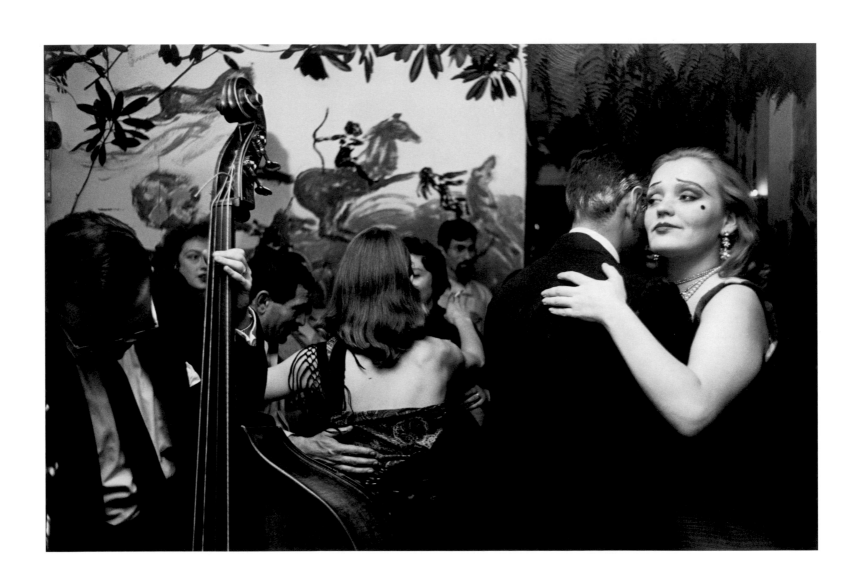

ELLIOTT ERWITT DANCING AT A PRIVATE PARTY IN DOWNTOWN MANHATTAN, 1955

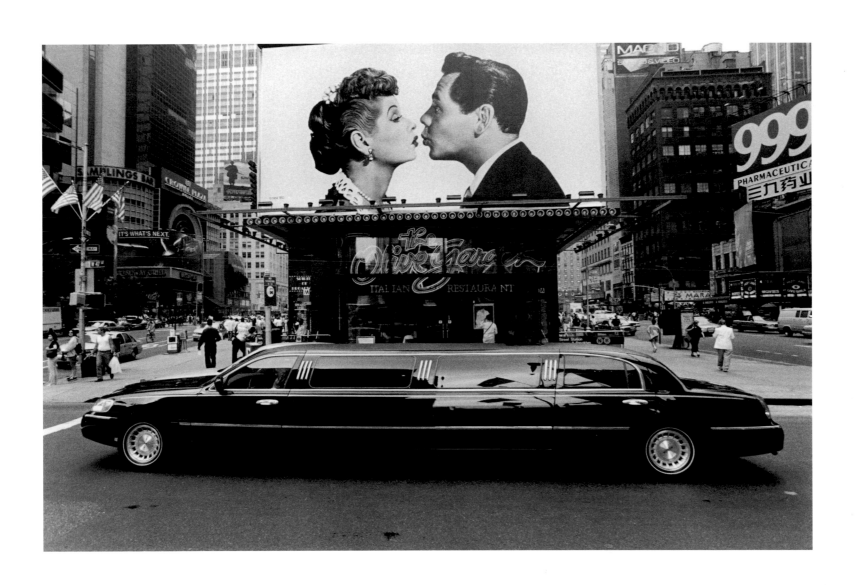

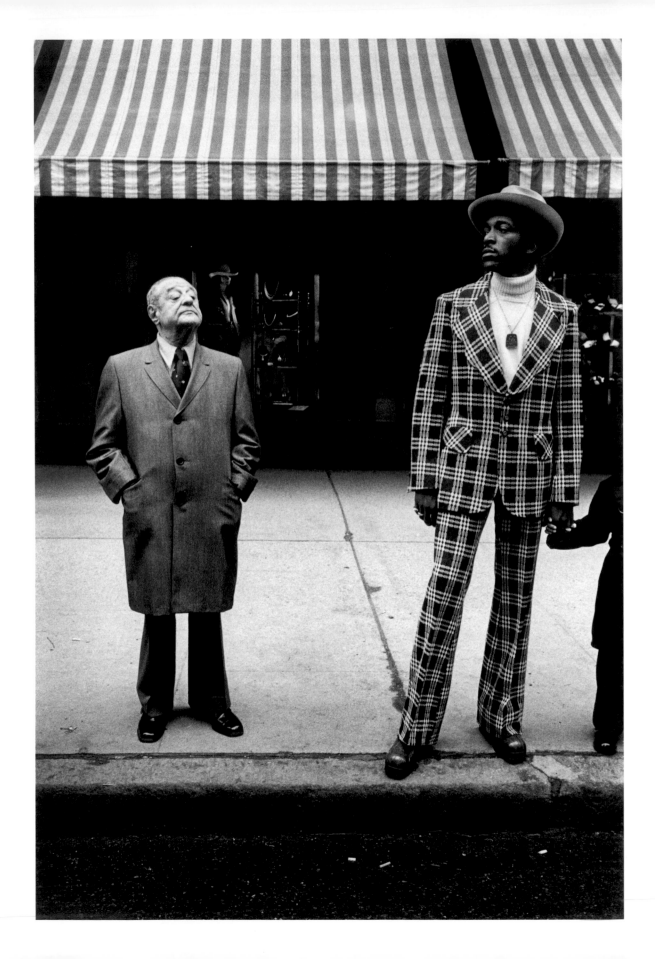

FERDINANDO SCIANNA KISS ON SUBWAY PLATFORM, CONEY ISLAND 1985

LIFE IS A PARTY

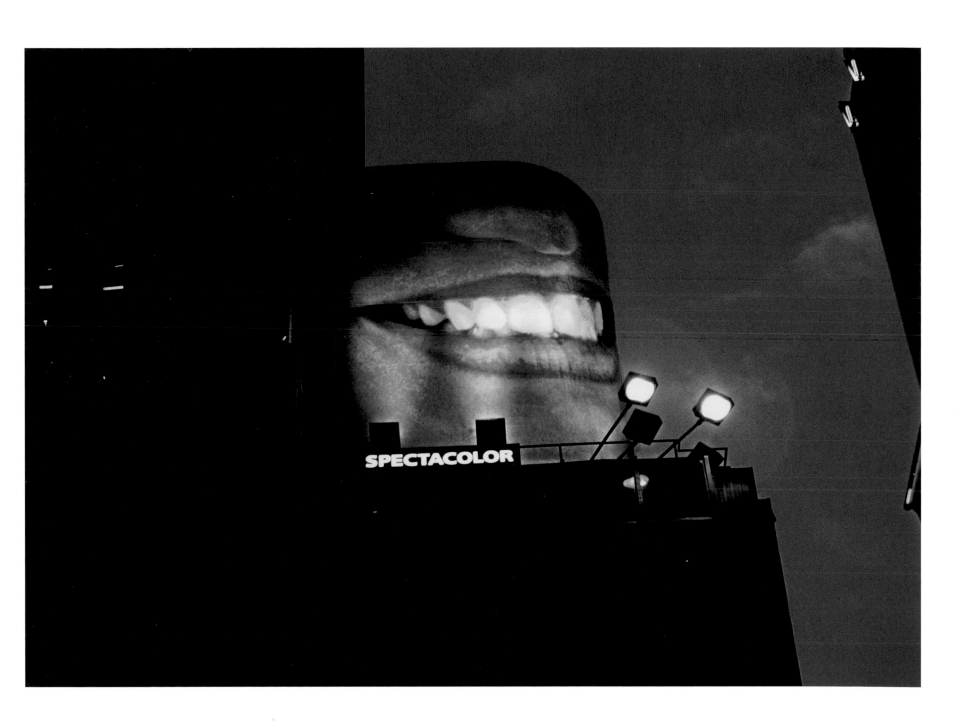

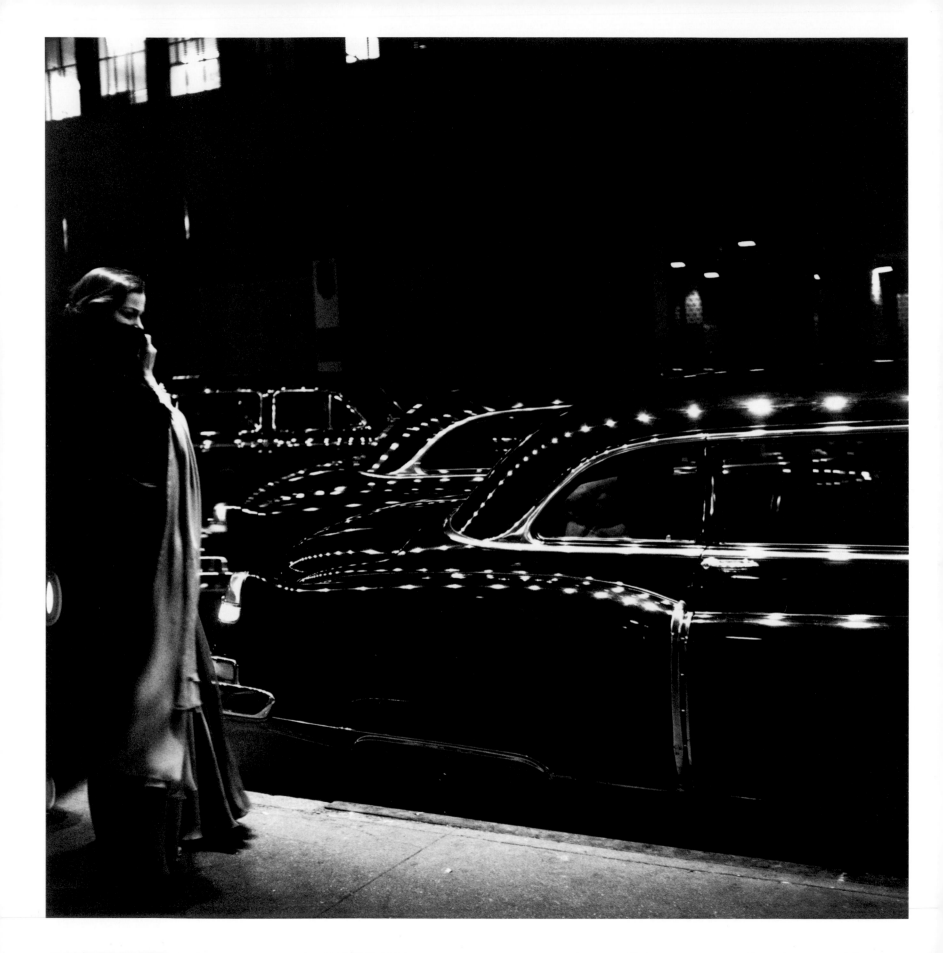

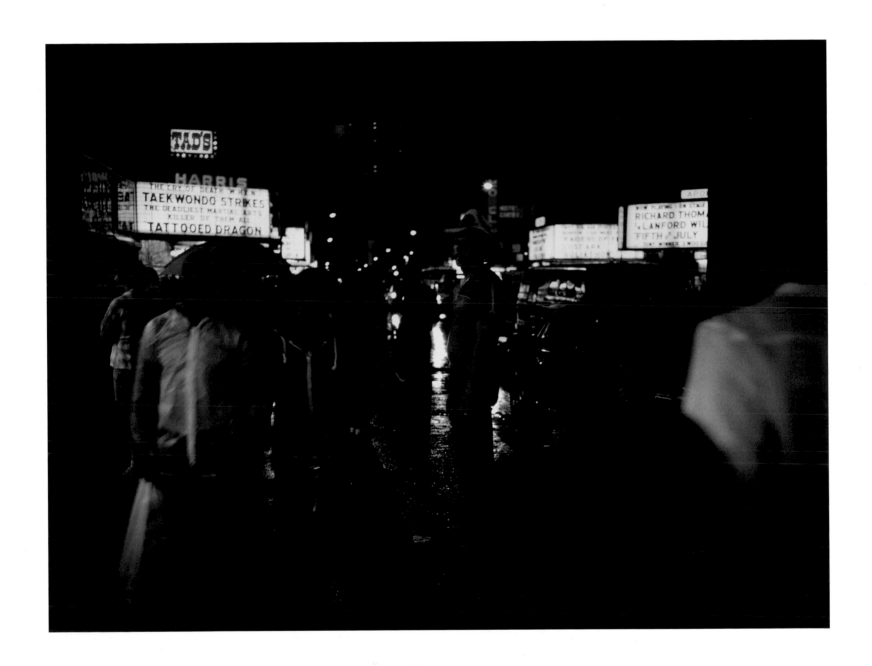

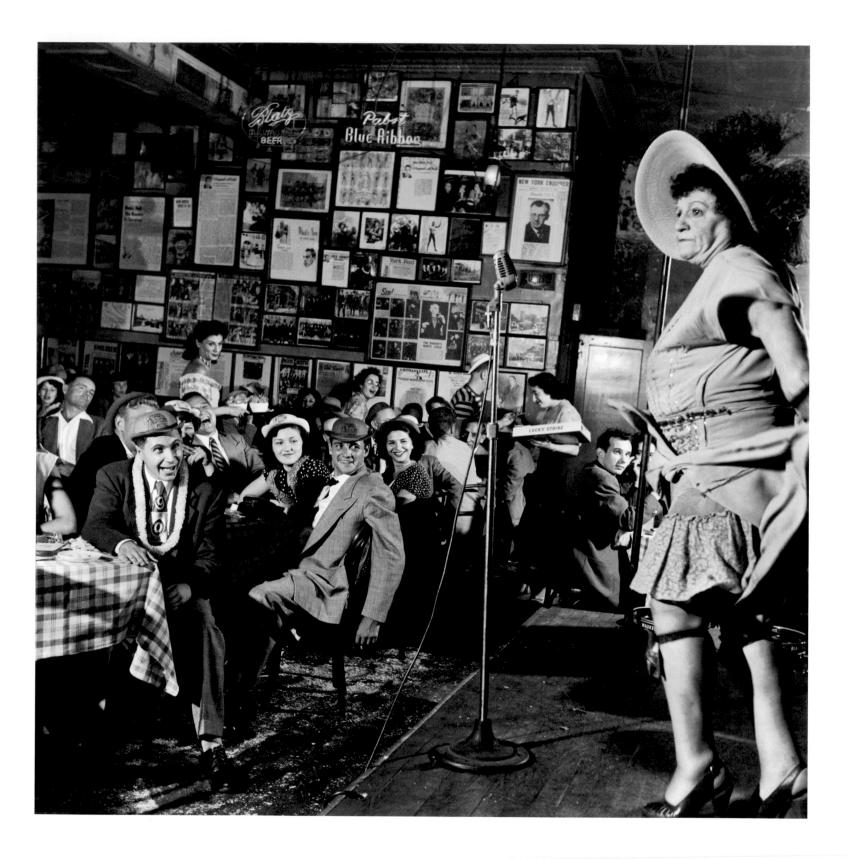

BURT GLINN SAMMY'S BOWERY FOLLIES, 1949

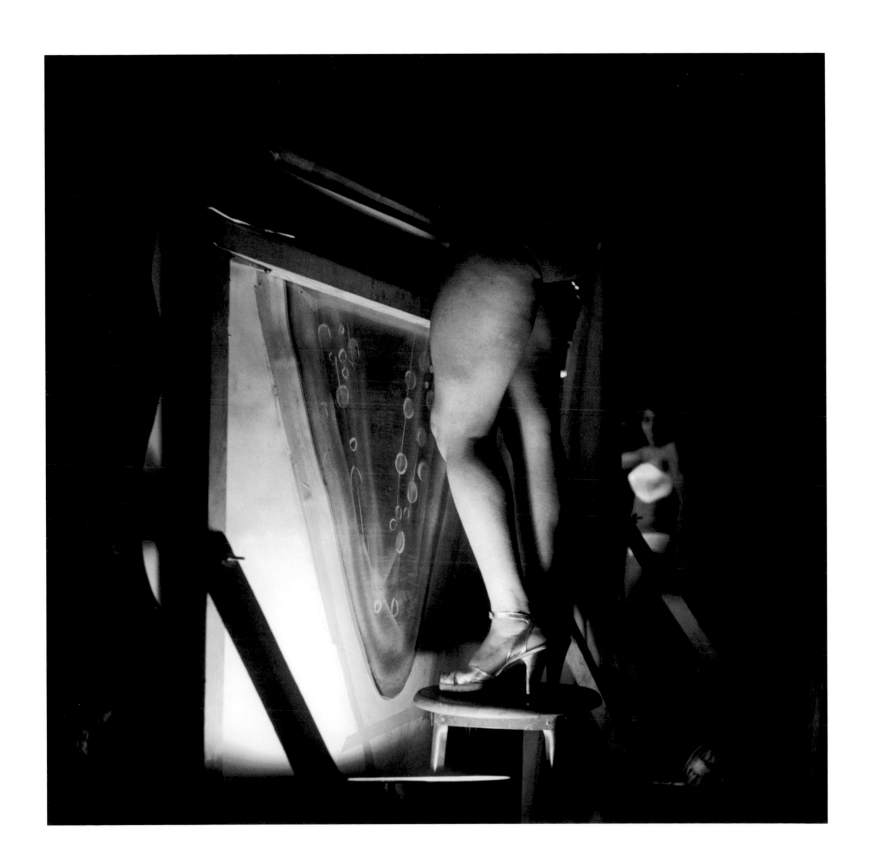

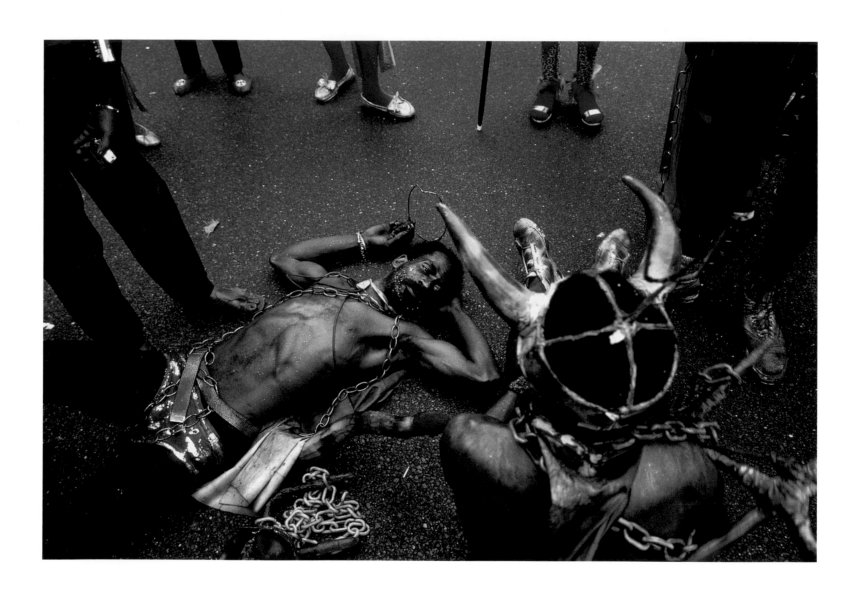

ALEX WEBB WEST INDIAN FESTIVAL ON THE EASTERN PARKWAY, BROOKLYN 1981

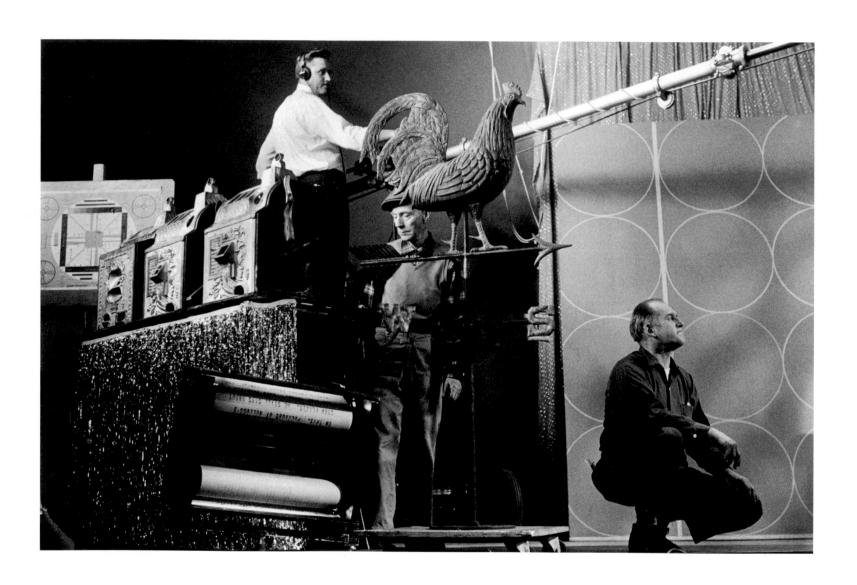

HENRI CARTIER-BRESSON CBS TELEVISION STUDIO, 1959

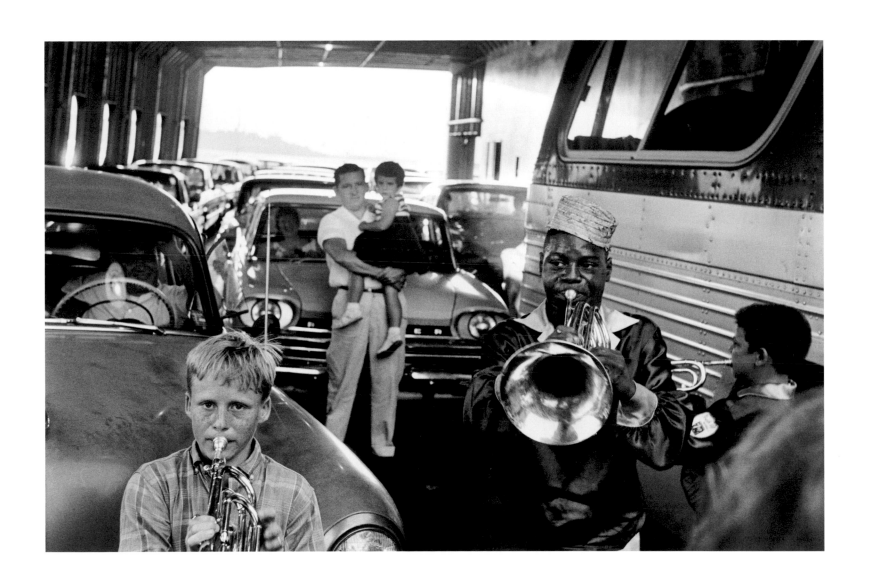

THESE THINGS HAPPEN

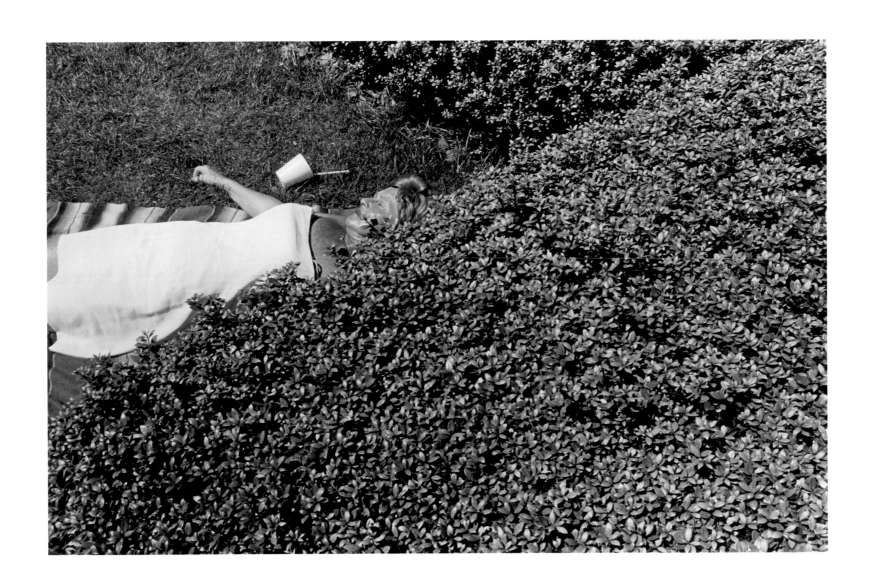

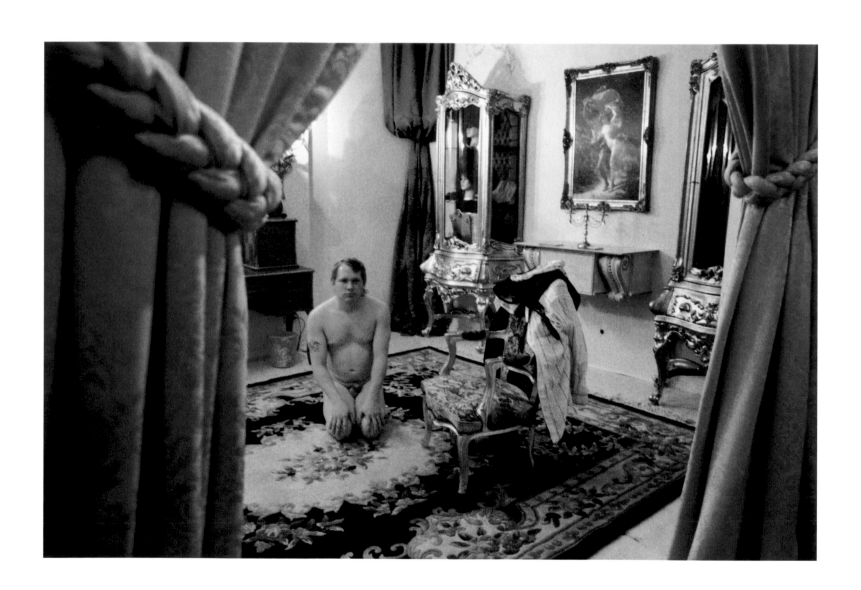

SUSAN MEISELAS AWAITING MISTRESS NATASHA IN THE VERSAILLES ROOM AT PANDORA'S BOX, A S & M LOFT IN CHELSEA, 1995

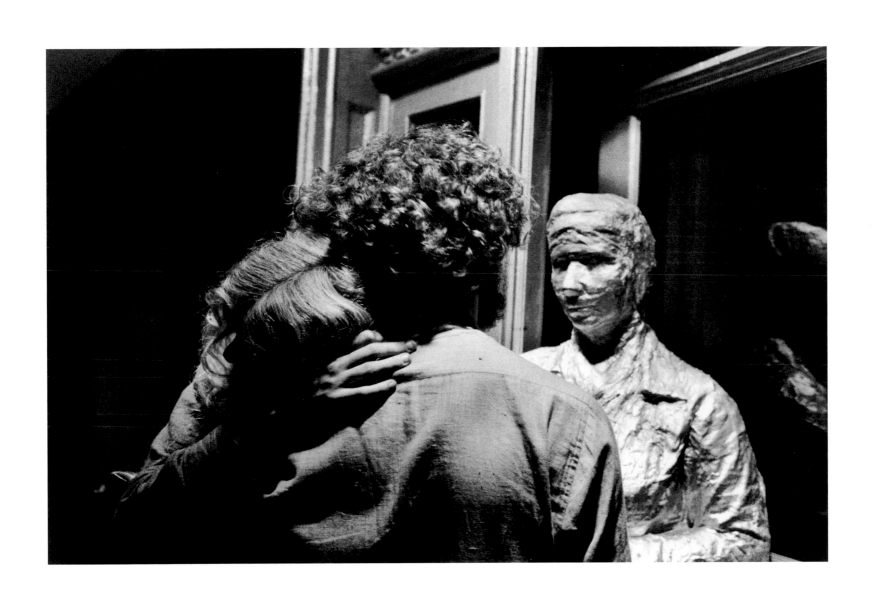

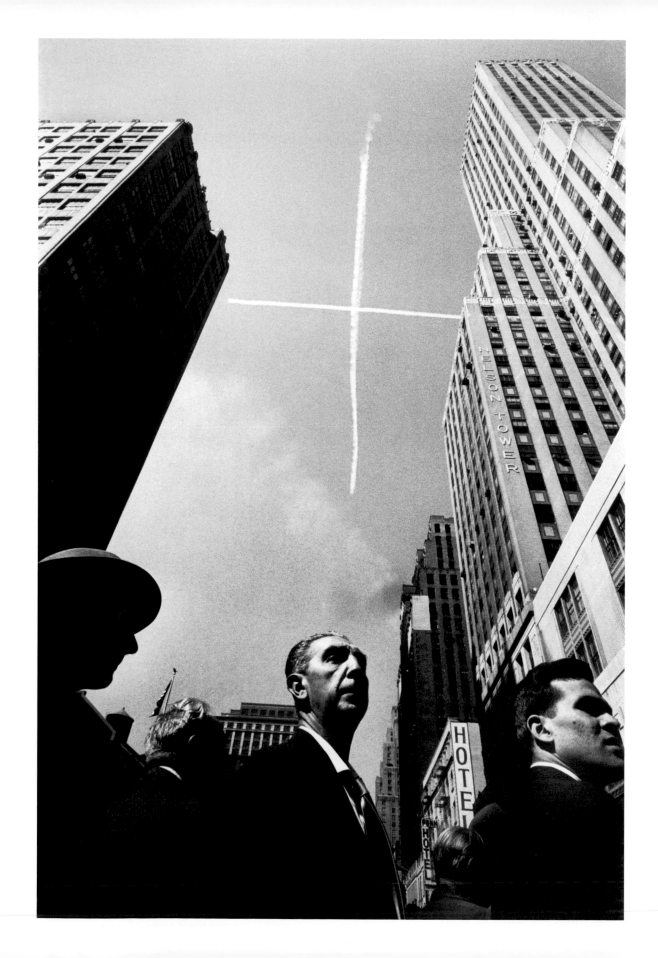

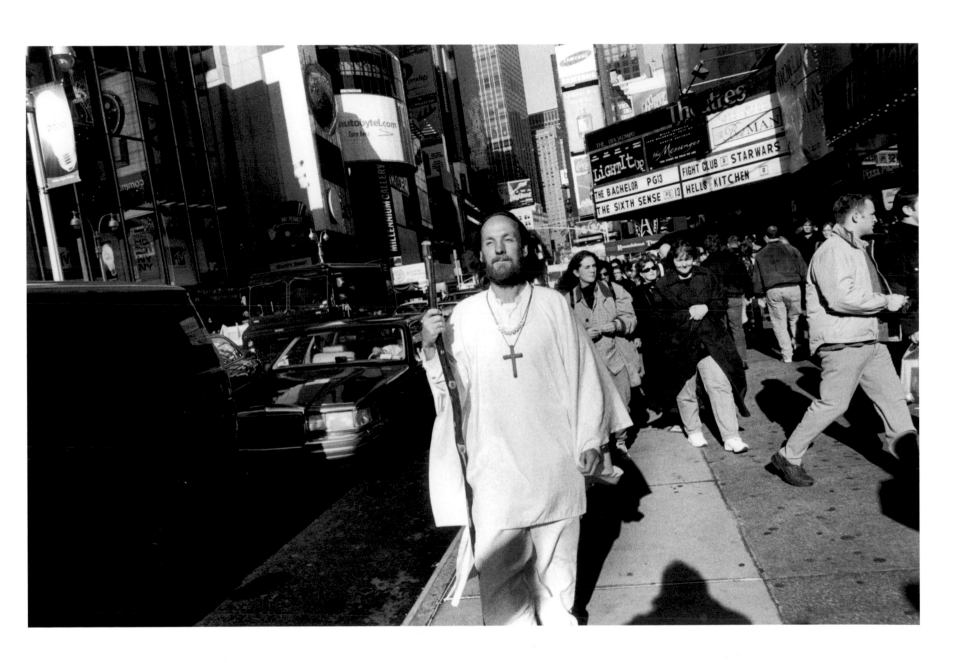

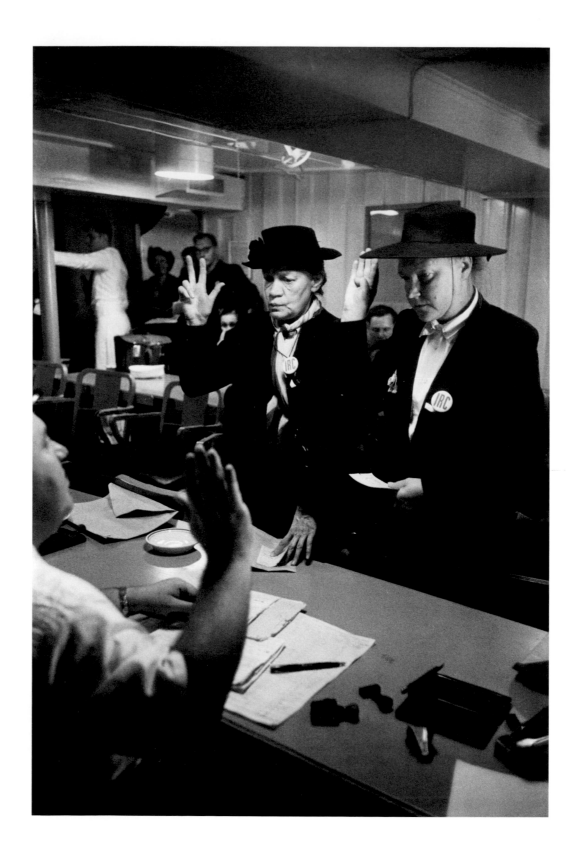

DENNIS STOCK CUSTOMS DEMANDING AN ASSURANCE OF "NO COMMUNIST AFFILIATION," 1951

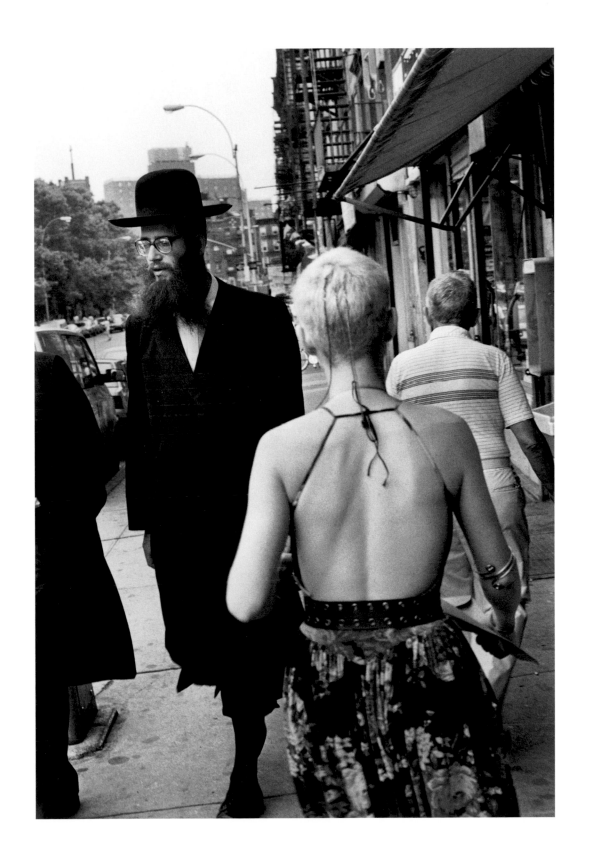

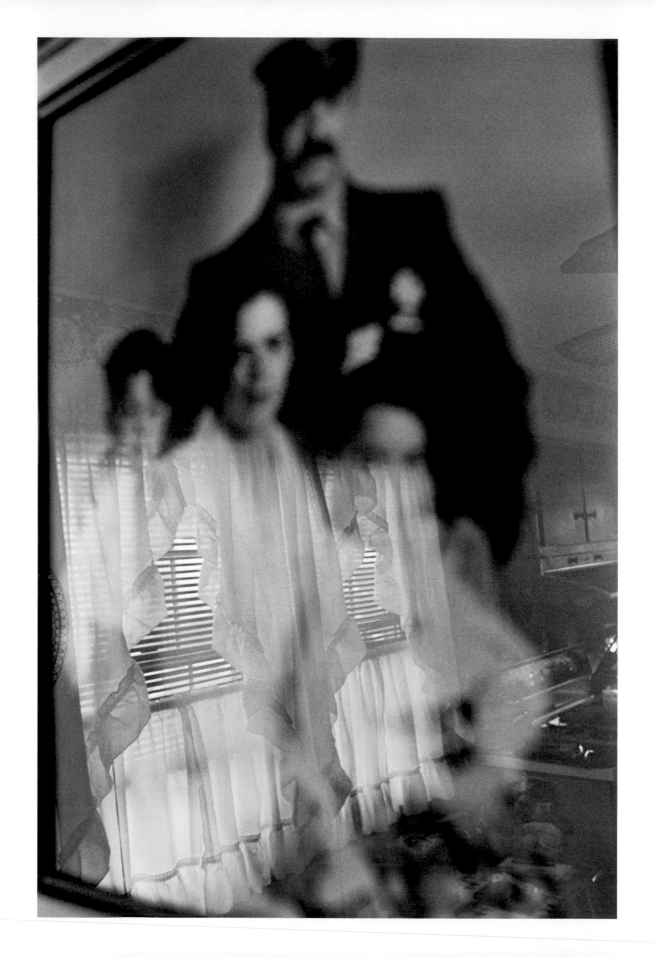

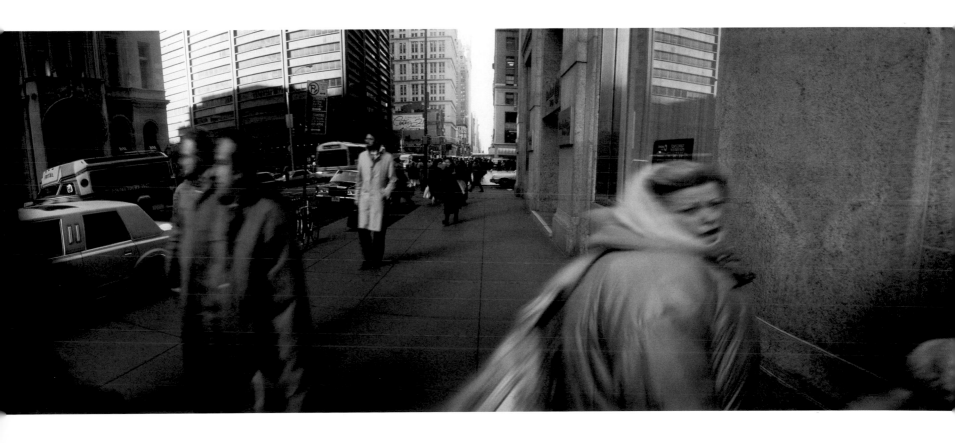

ON THE GO

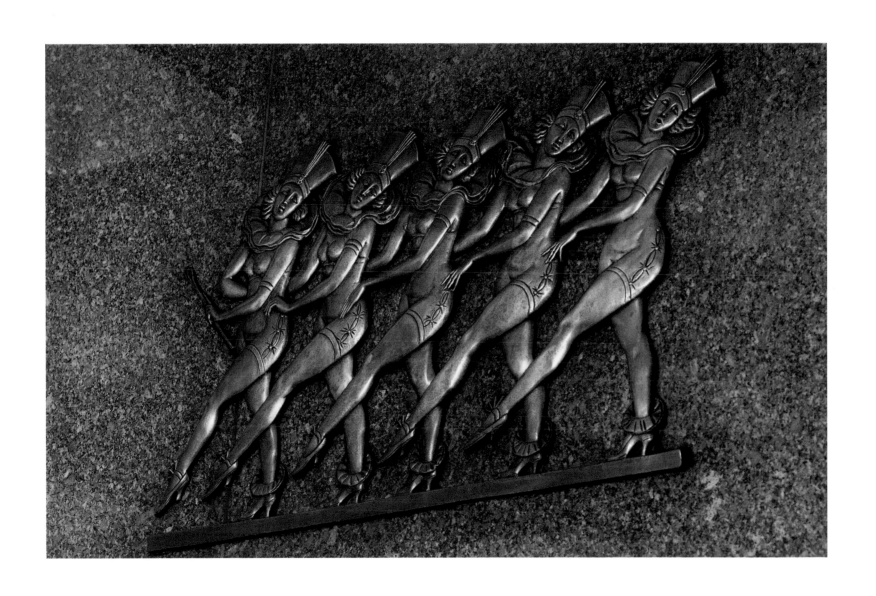

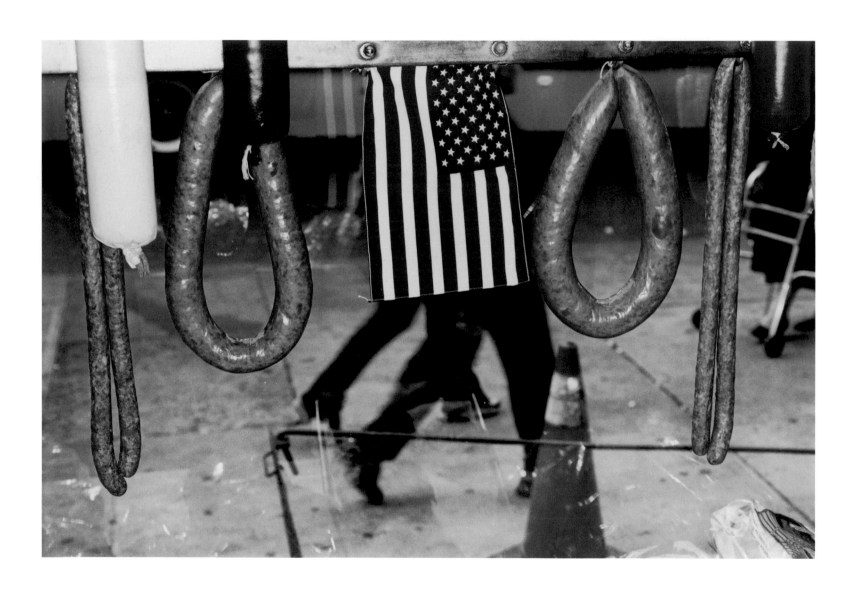

MARTIN PARR BUTCHER SHOP WINDOW IN DOWNTOWN MANHATTAN, 2001

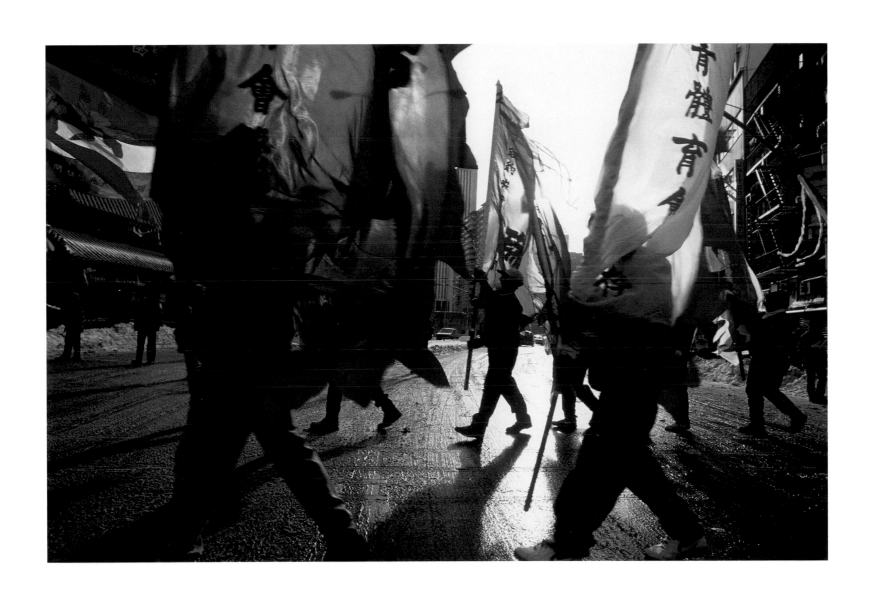

CHIEN-CHI CHANG MEMBERS OF A KUNG FU SCHOOL MARCH TO CELEBRATE THE CHINESE NEW YEAR ON THE BOWERY IN CHINATOWN, 1996 63

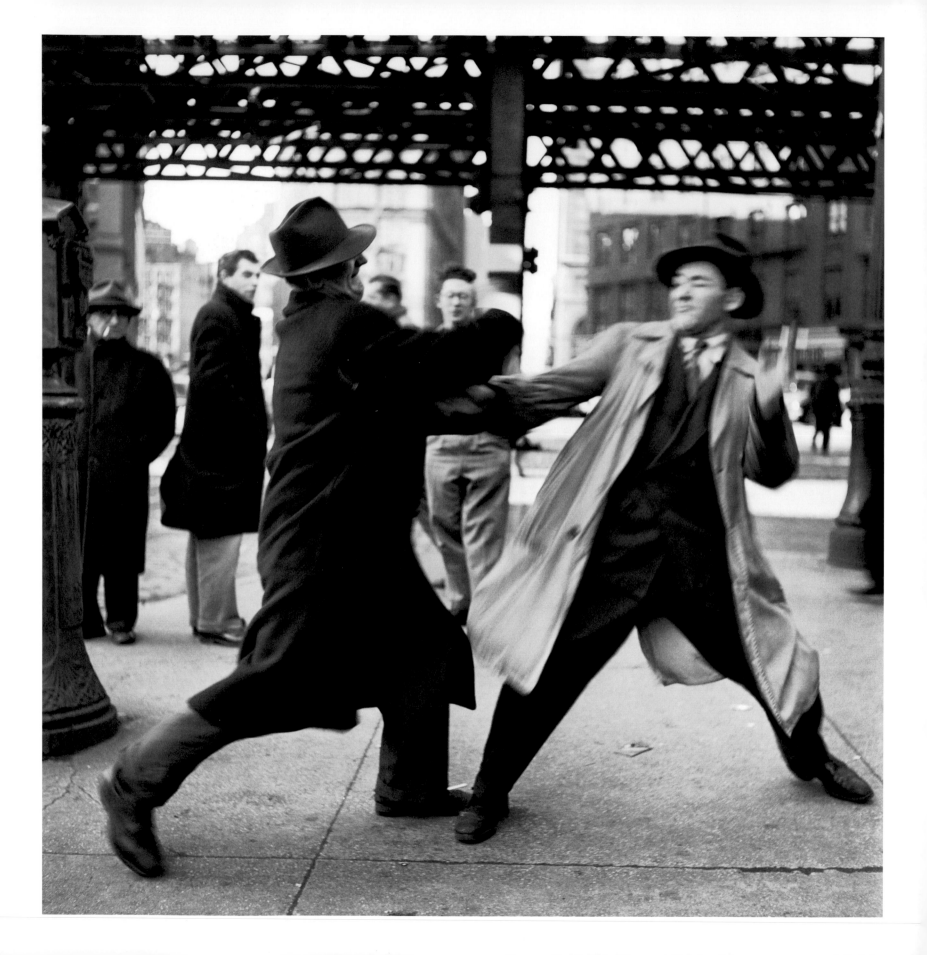

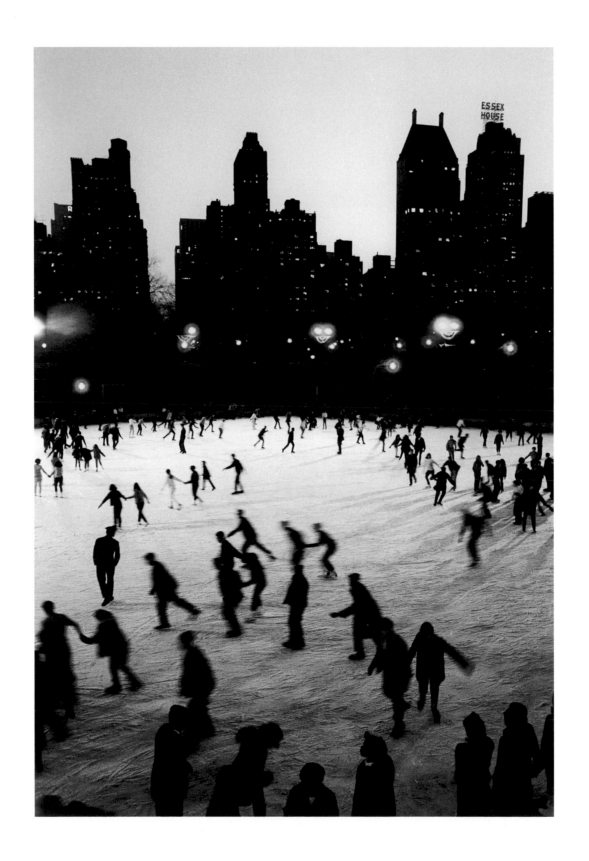

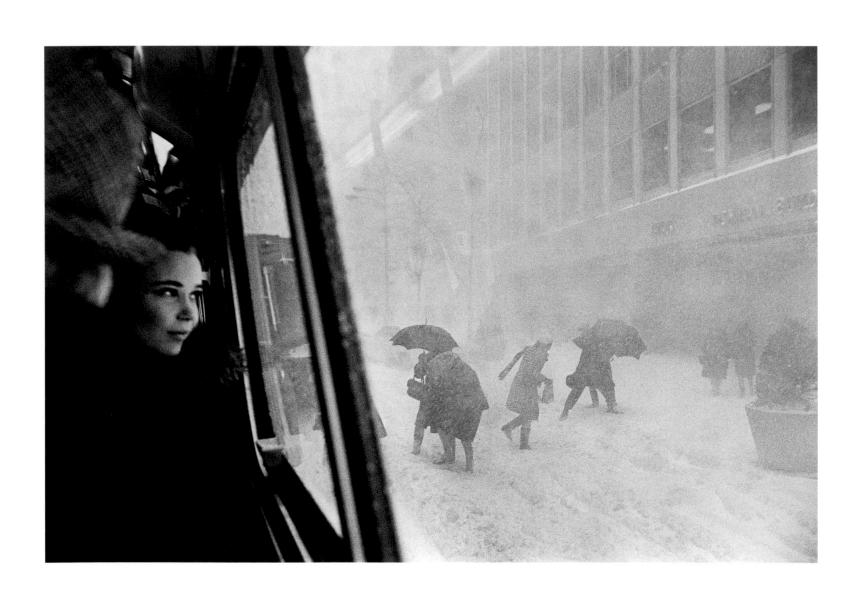

66 **ERICH HARTMANN** YOUNG WOMAN ON A BUS IN MIDTOWN DURING A SNOWSTORM, 1967

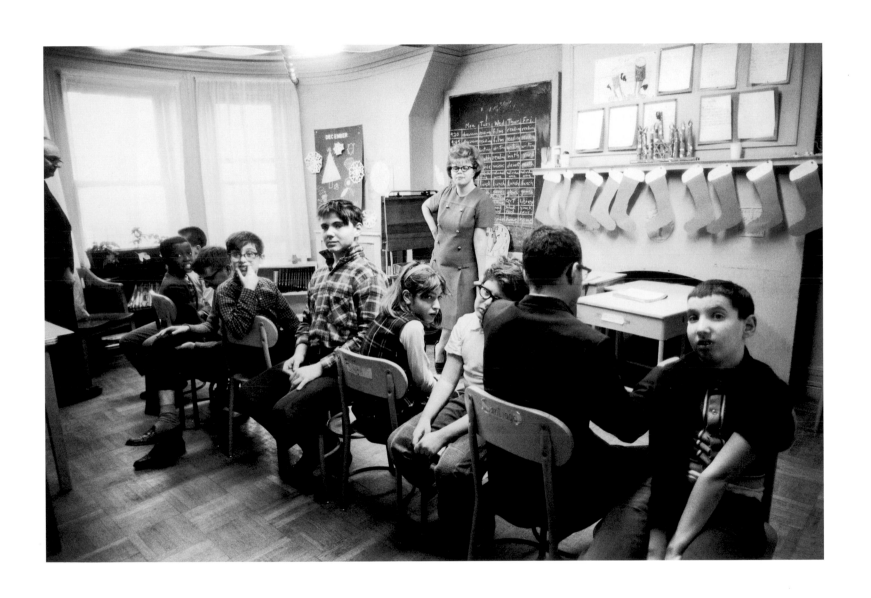

STUART FRANKLIN CHILD PLAYING AT THE SOUTHERN END OF CENTRAL PARK, 1988

BRUCE DAVIDSON RICKY HENDERSON SLIDING INTO THIRD BASE AT YANKEE STADIUM IN THE BRONX, 1984

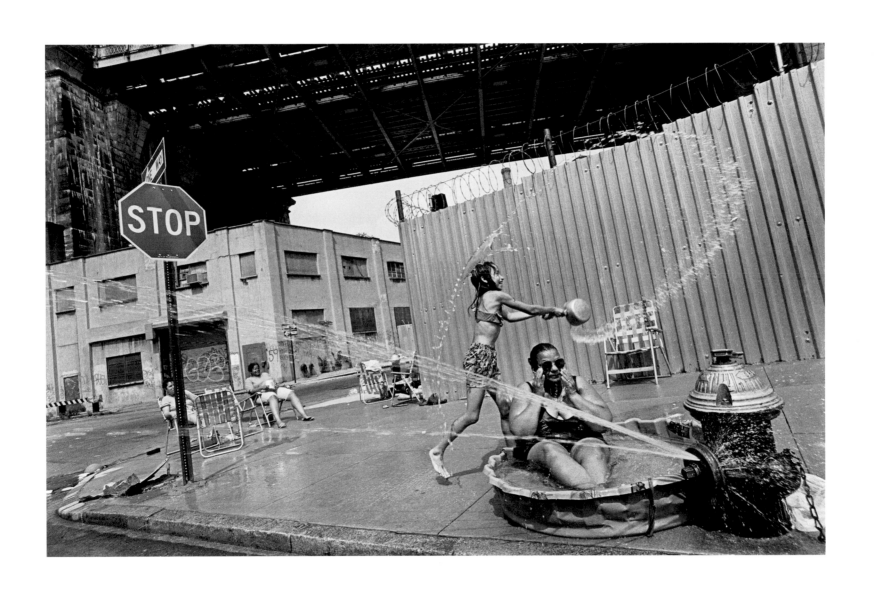

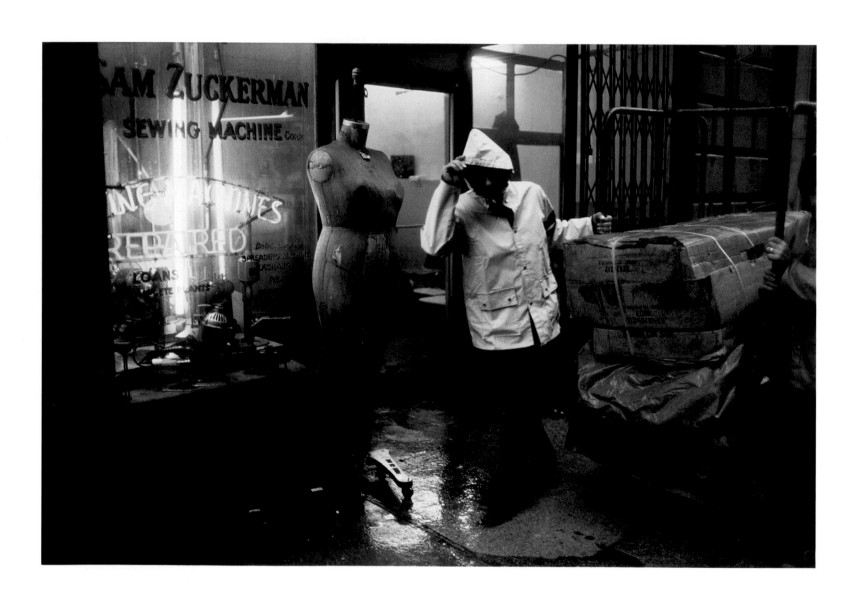

THOMAS HOEPKER RAINY MORNING IN MANHATTAN'S GARMENT DISTRICT ON 25TH STREET, 1983

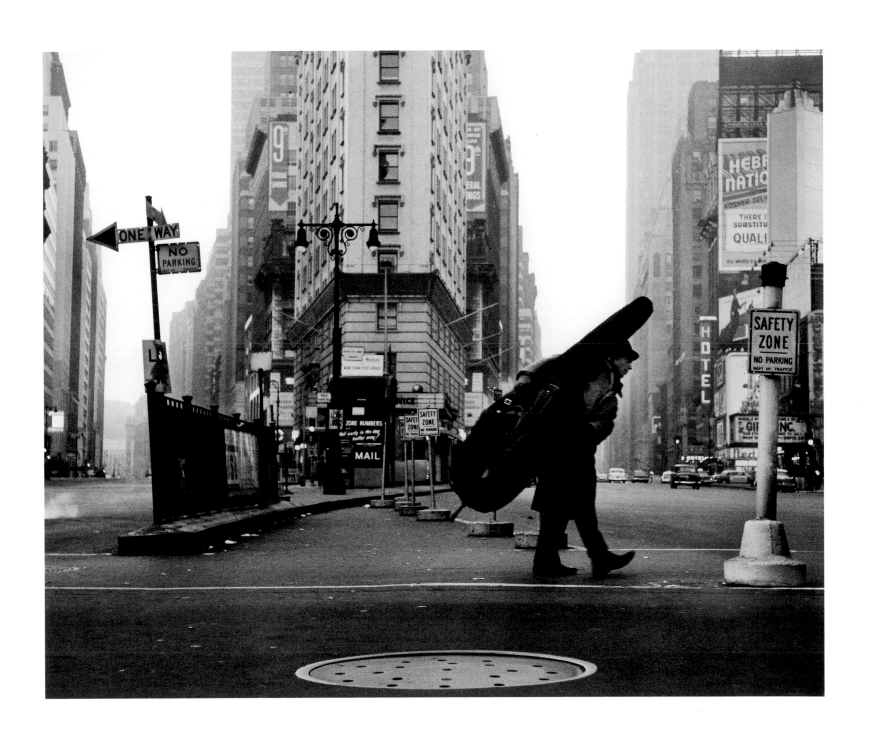

QUANDARIES

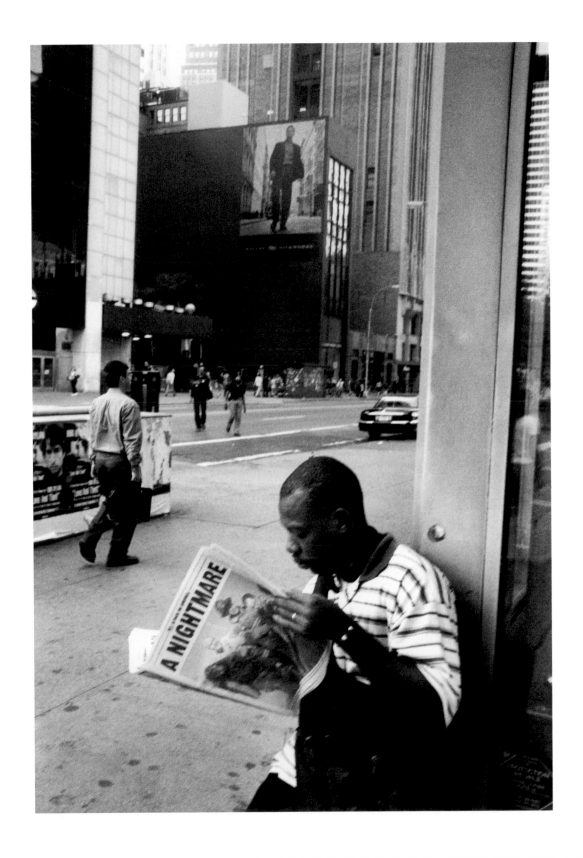

MARC RIBOUD MAN READING NEWSPAPER IN TIMES SQUARE THE DAY AFTER WORLD TRADE CENTER ATTACK, 2001 75

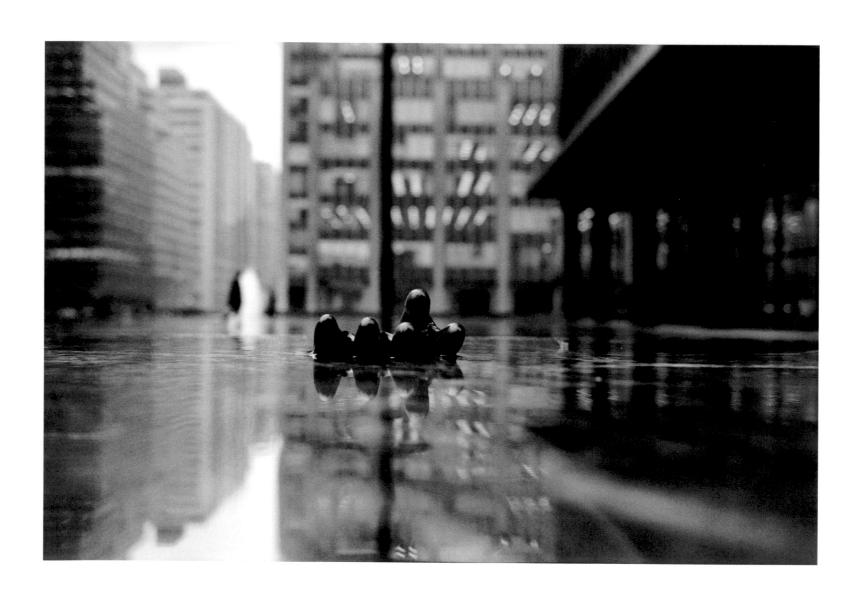

RICHARD KALVAR GLOVE IN A PUDDLE ON PARK AVENUE IN MIDTOWN, 1970

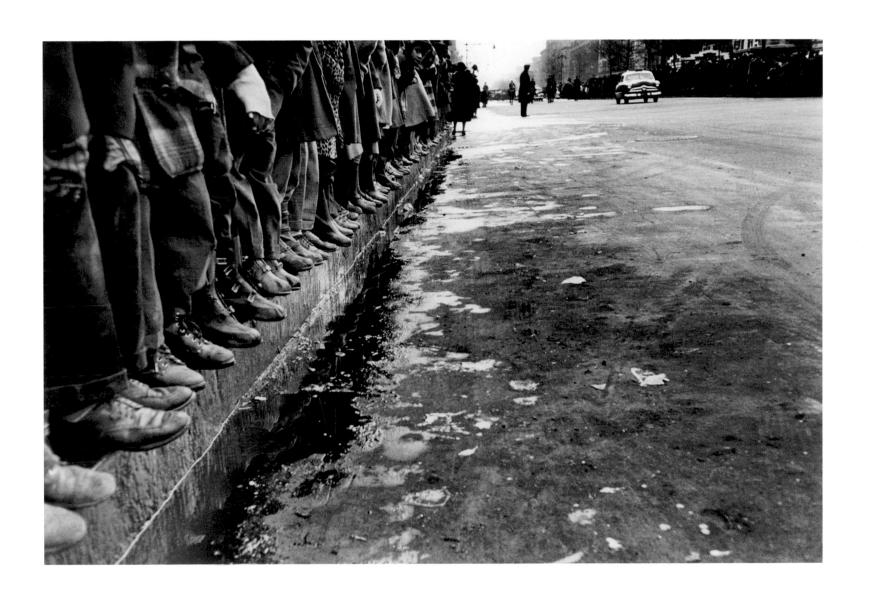

CORNELL CAPA CROWDS LINE BROADWAY IN HARLEM AWAITING THE FUNERAL PROCESSION OF WILLIAM "BOJANGLES" ROBINSON, 1949 77

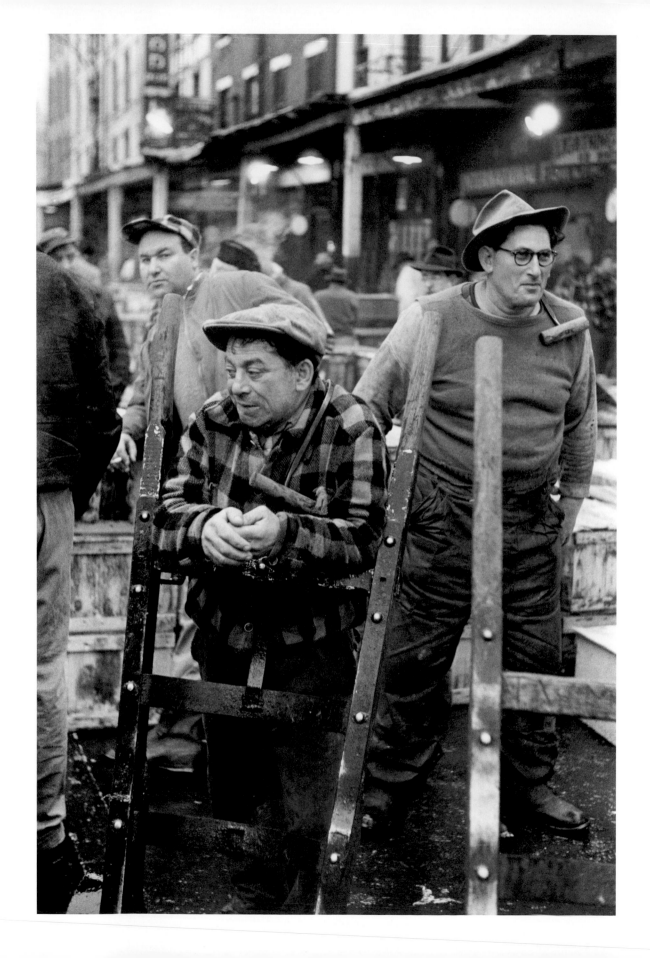

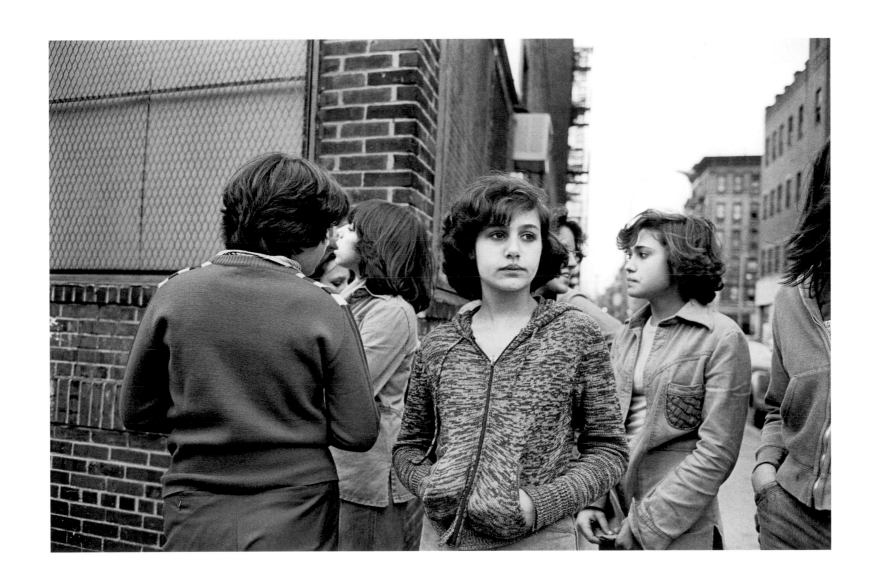

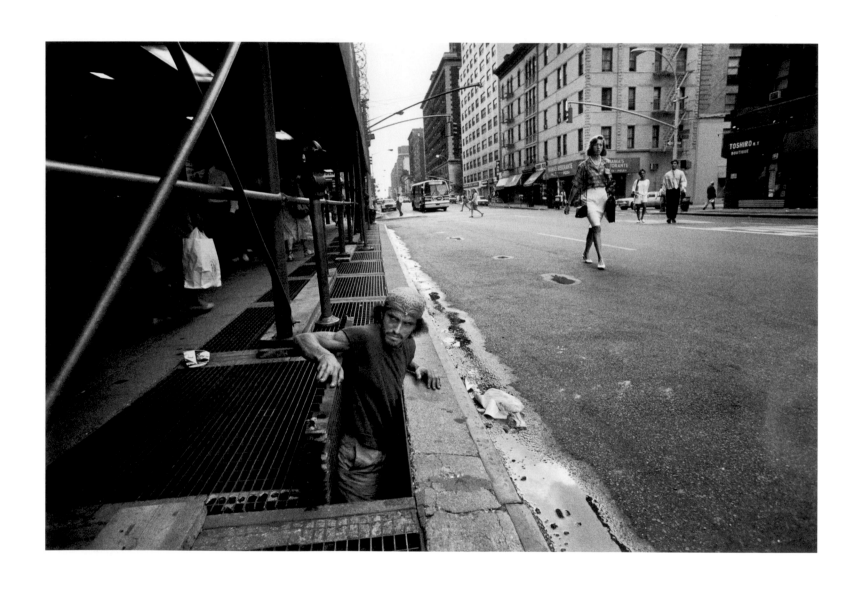

EUGENE RICHARDS TOM, A PANHANDLER, EMERGING FROM A SUBWAY VENT ON THE UPPER EAST SIDE, 1998

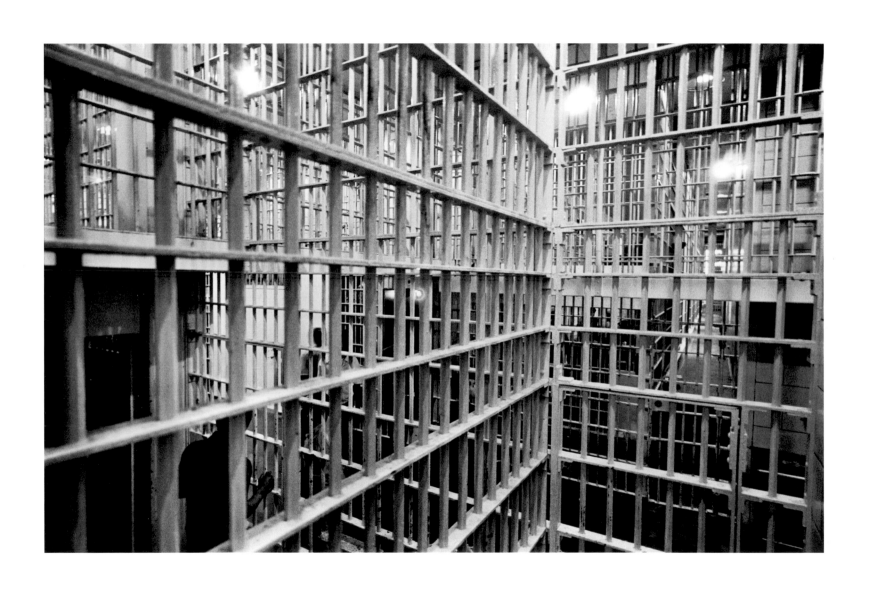

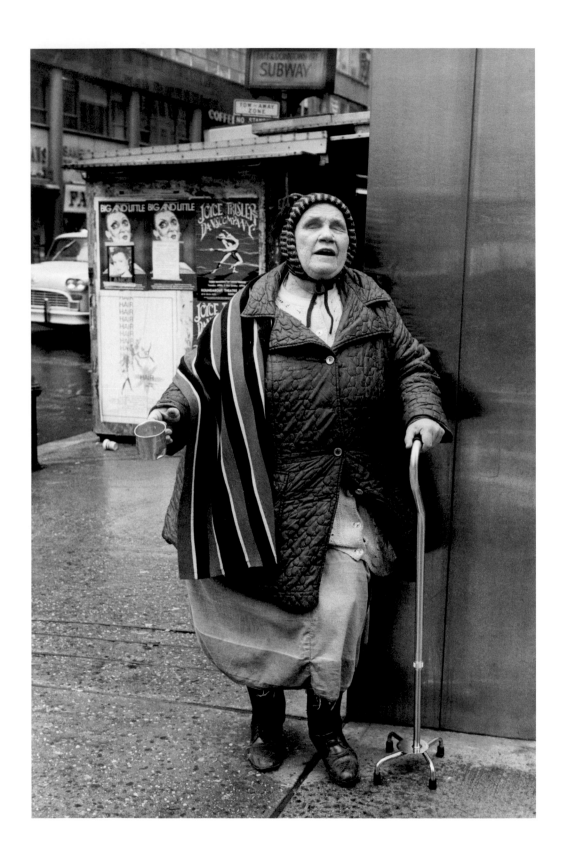

MARTINE FRANCK BLIND WOMAN BEGGING IN MIDTOWN, 1979

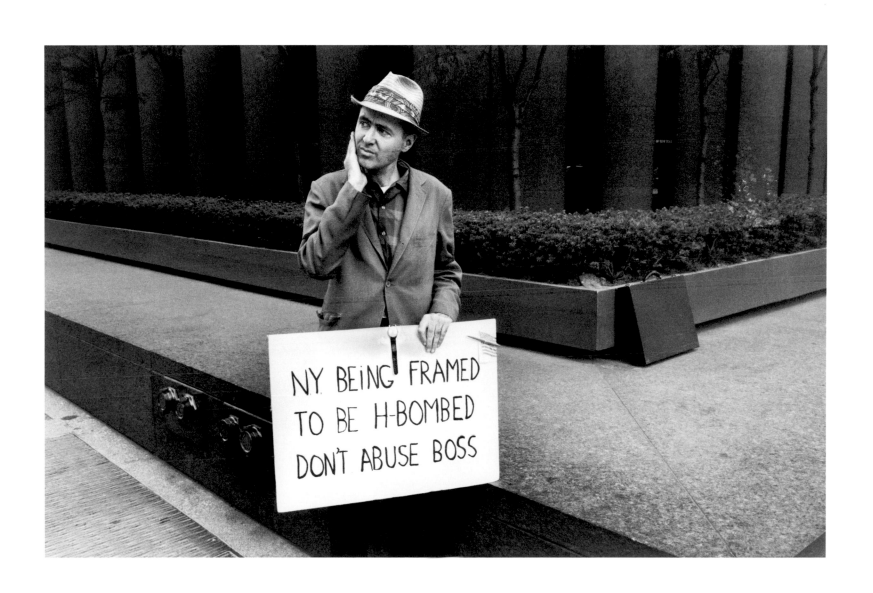

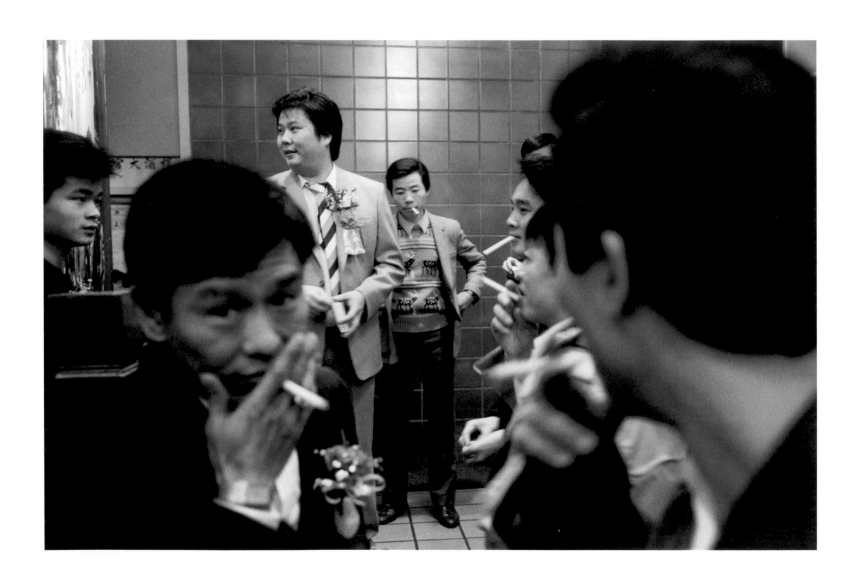

∧ **PATRICK ZACHMANN** MEN SMOKING IN CHINATOWN, 1987 > **LEONARD FREED** THREE GIRLS AT A STREETFAIR IN HARLEM, 1963

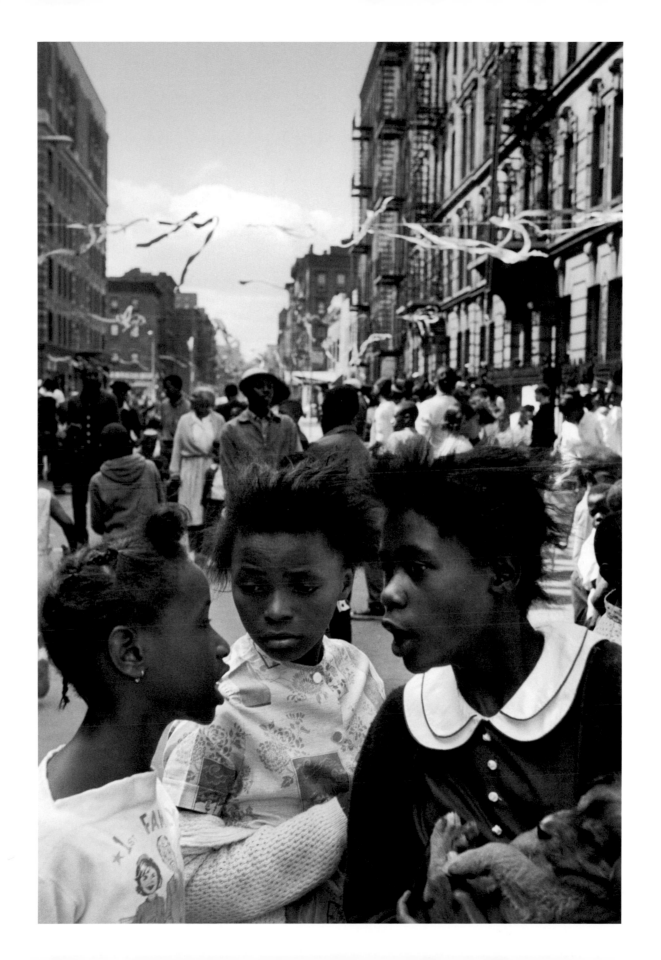

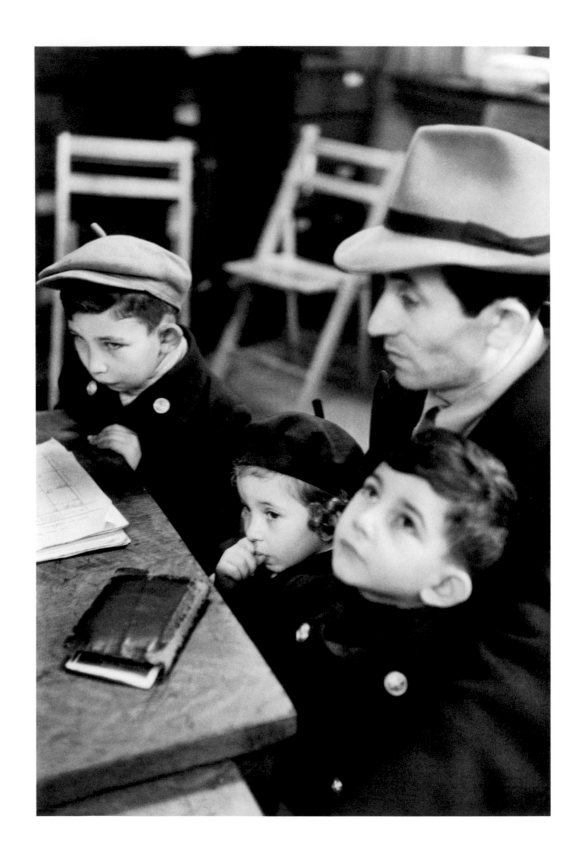

BURT GLINN FATHER WITH CHILDREN ON THE FIRST DAY OF THE ENACTMENT OF THE ALIEN REGISTRATION ACT, 1951

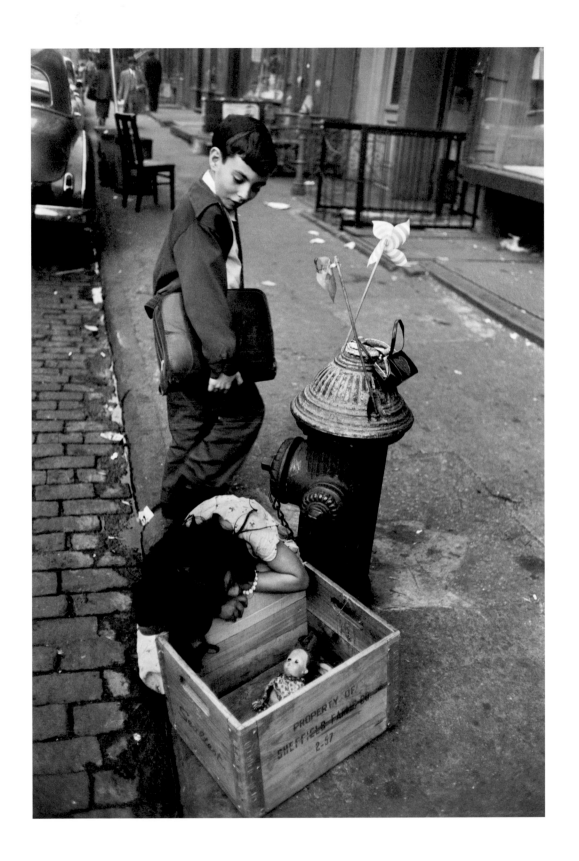

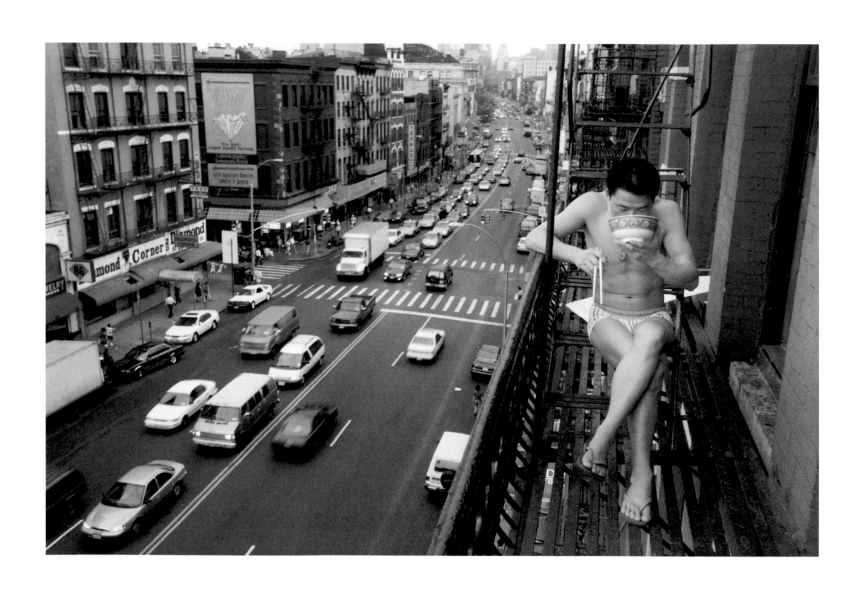

CHIEN-CHI CHANG NEWLY ARRIVED CHINESE IMMIGRANT ON A FIRE ESCAPE ON THE BOWERY IN CHINATOWN, 1998

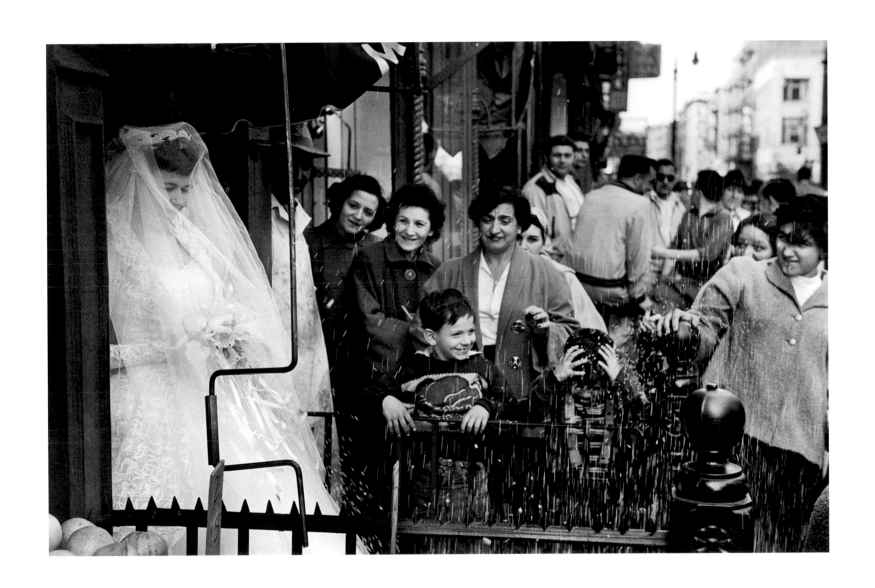

WE ARE INNOCENT

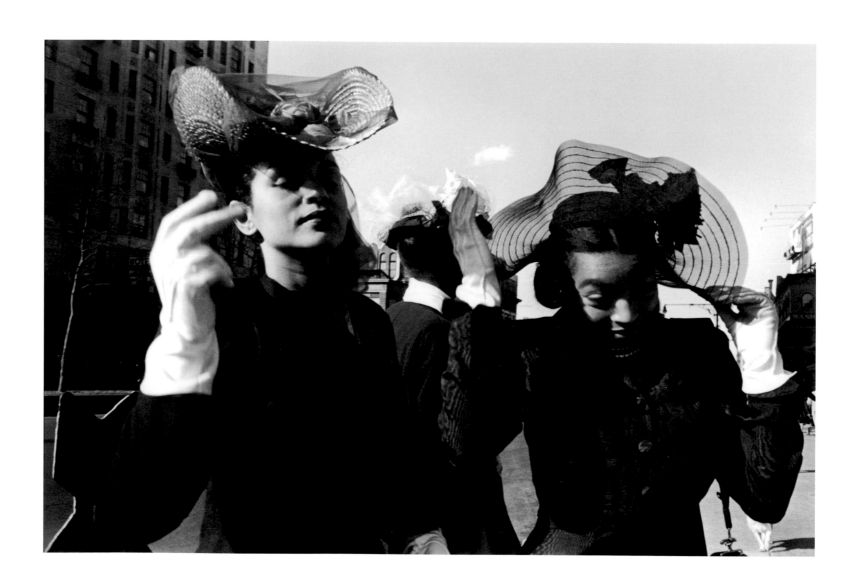

HENRI CARTIER-BRESSON EASTER SUNDAY IN HARLEM, 1947

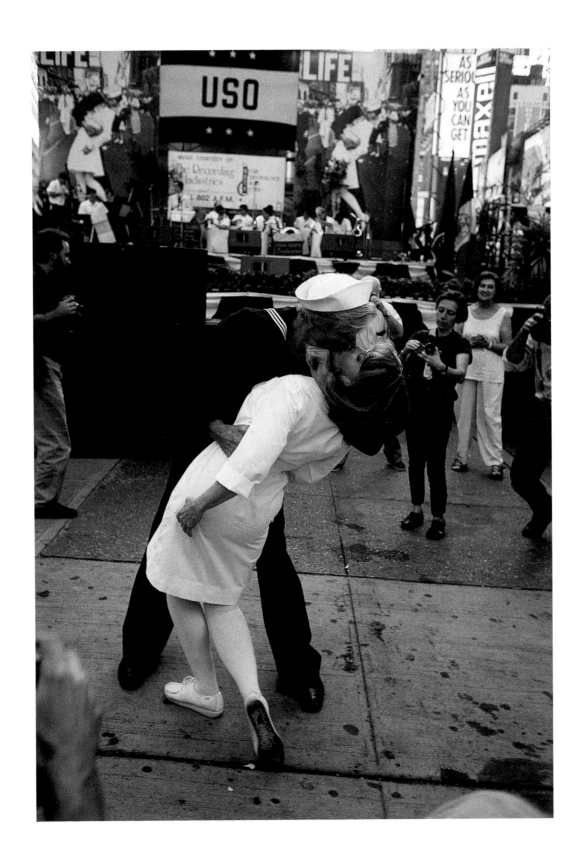

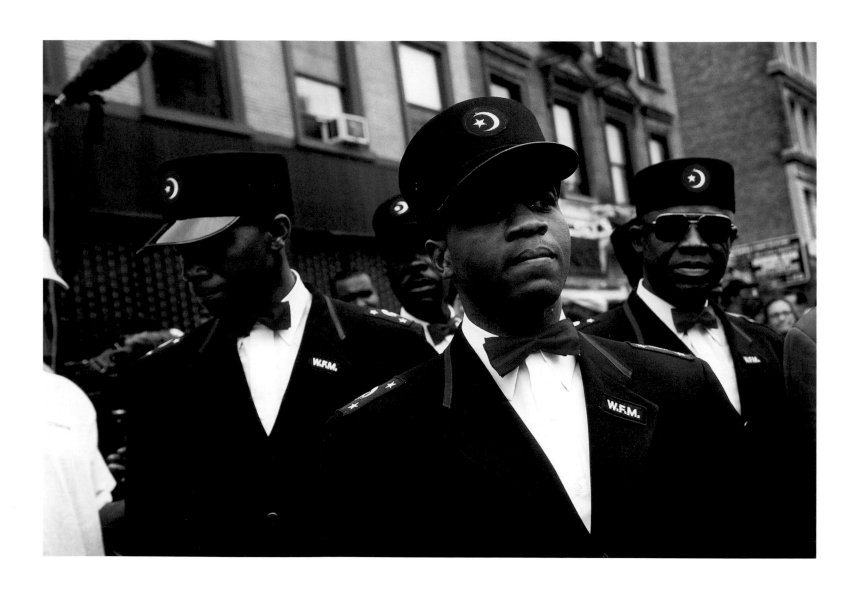

ELI REED MEMBERS OF THE NATION OF ISLAM AT THE SECOND MILLION YOUTH MARCH IN HARLEM, 1999

CORNELL CAPA STATE DEMOCRATIC CONVENTION AT THE ARMORY IN MURRAY HILL, 1954

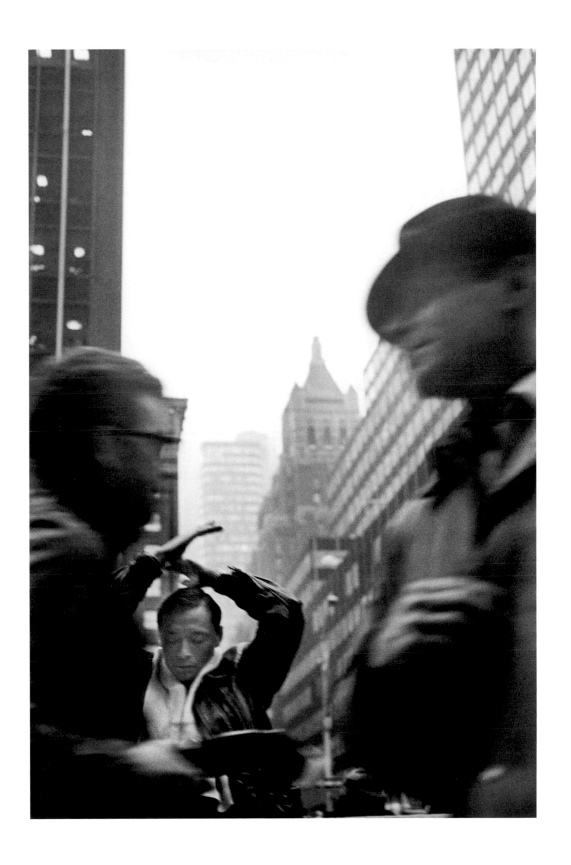

LARRY TOWELL FALUN GONG PRACTICIONER MEDITATES IN PROTEST IN FRONT OF THE CHINESE CONSULATE, 2002

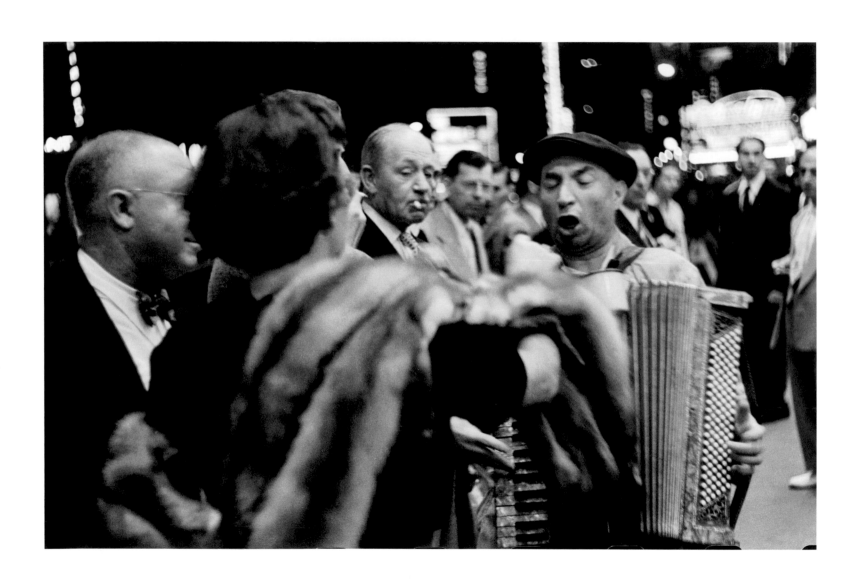

ELLIOTT ERWITT ACCORDIAN PLAYER IN THE THEATER DISTRICT, 1950

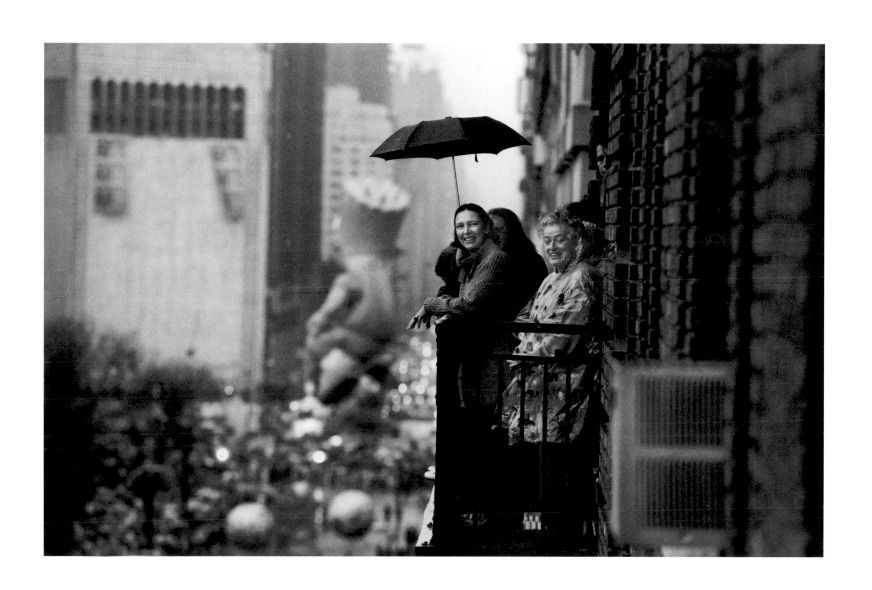

BURT GLINN BALCONY OVERLOOKING THE THANKSGIVING DAY PARADE ON CENTRAL PARK WEST, 1992 99

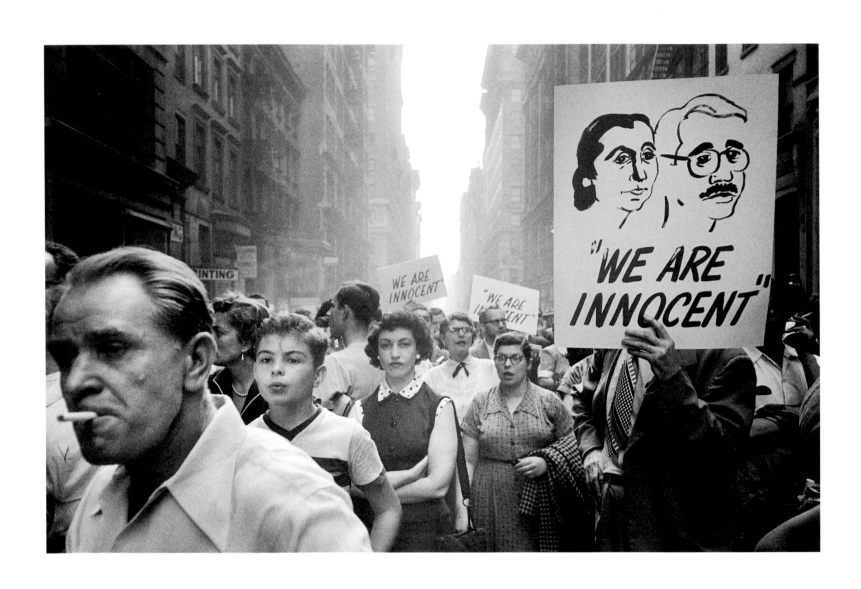

DENNIS STOCK PROTESTERS OUTSIDE THE TRIAL OF ACUSSED SPIES JULIUS AND ETHEL ROSENBERG IN LOWER MANHATTAN, 1951

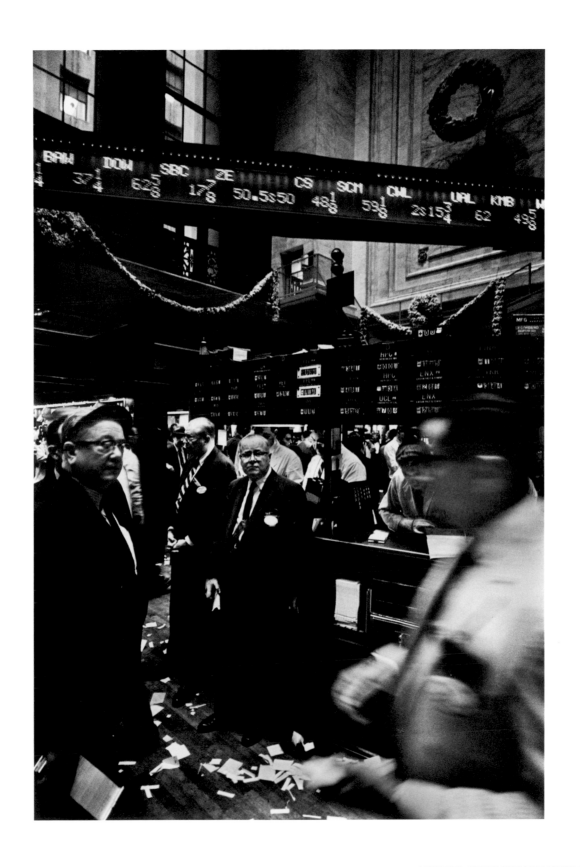

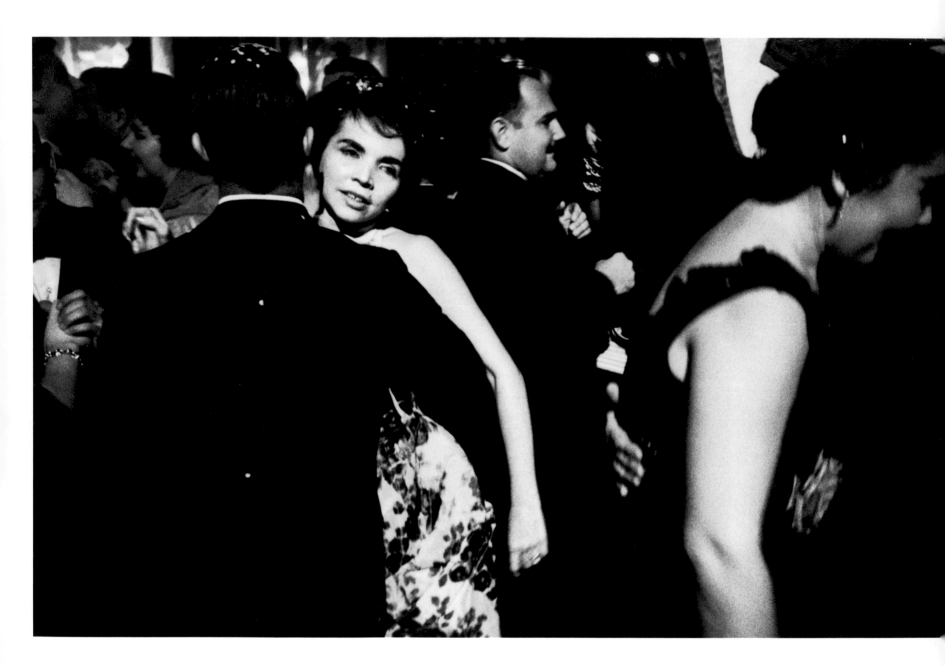

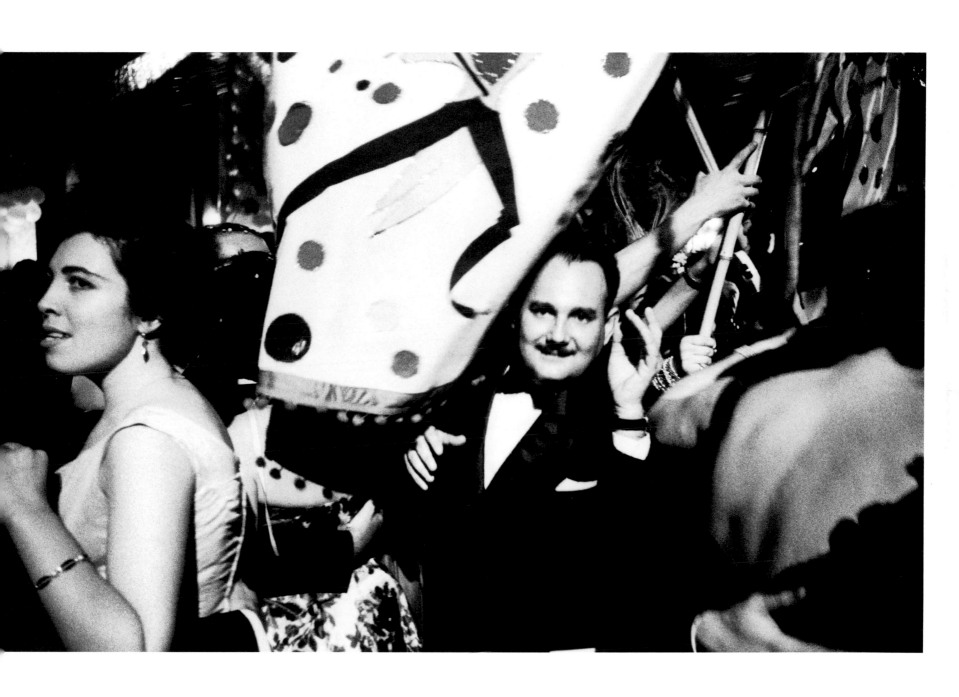

INGE MORATH BRAZILIAN BALL AT THE PIERRE HOTEL ON FIFTH AVENUE ON THE UPPER EAST SIDE, 1958 103

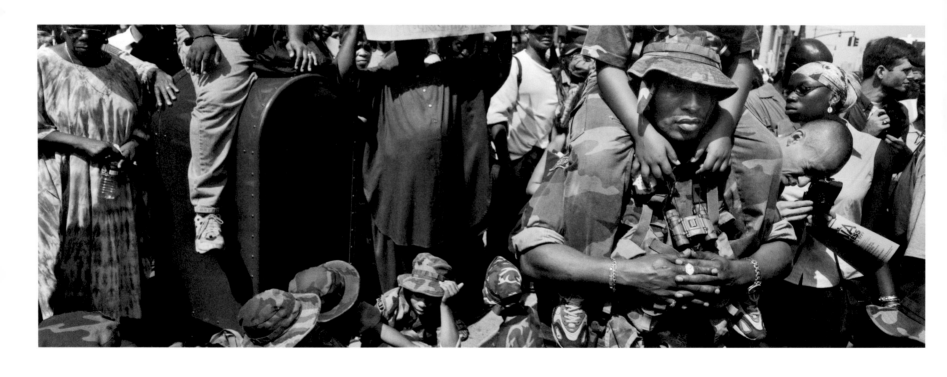

ELI REED PARTICIPANTS AT THE SECOND MILLION YOUTH MARCH IN HARLEM, 1999

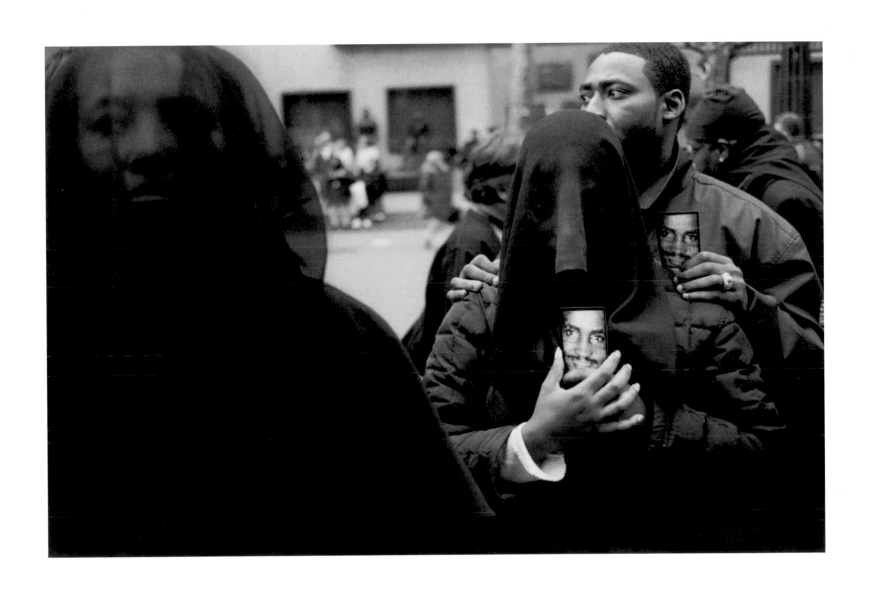

TRANSPORTED

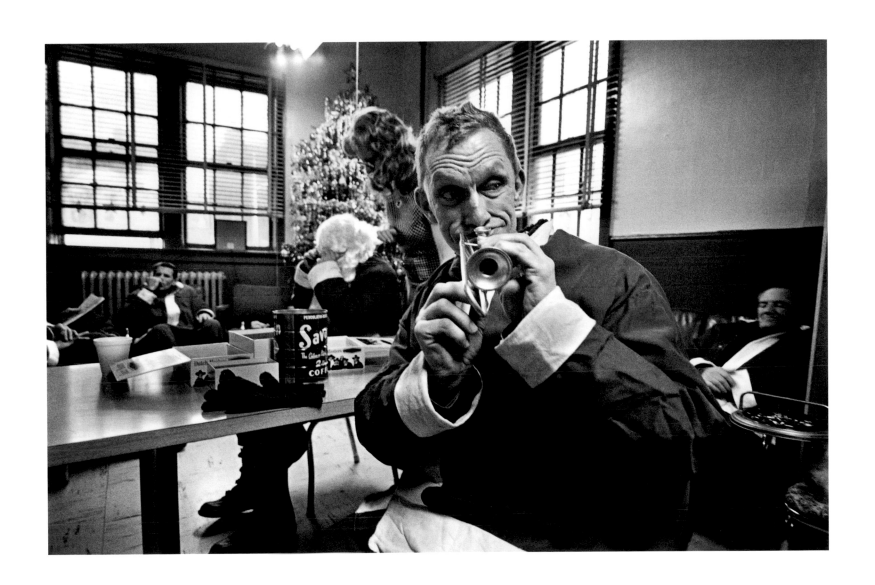

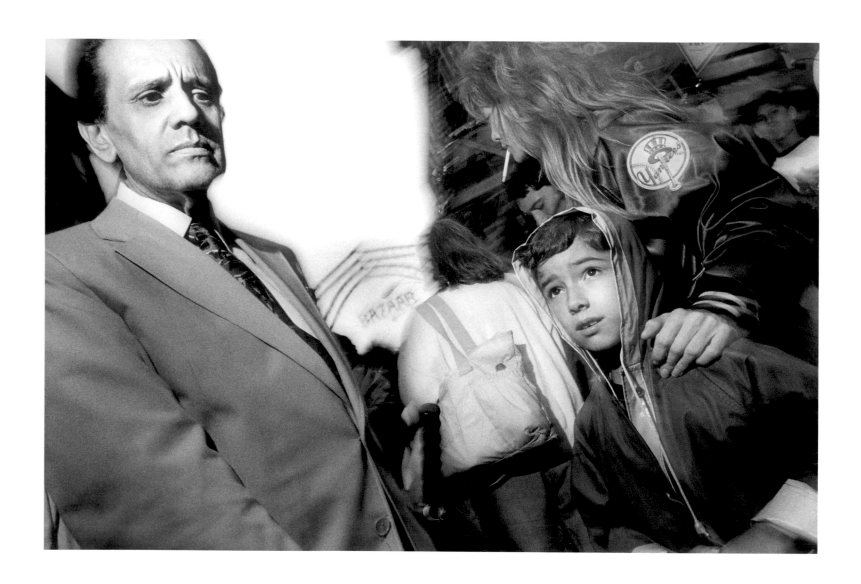

BRUCE GILDEN FEAST OF SAN GENNARO STREET FESTIVAL IN LITTLE ITALY, 1989

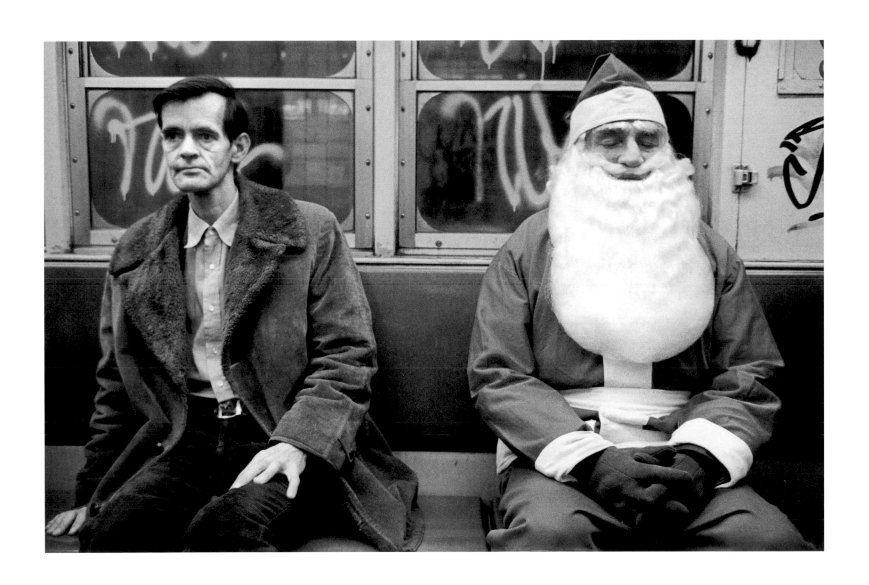

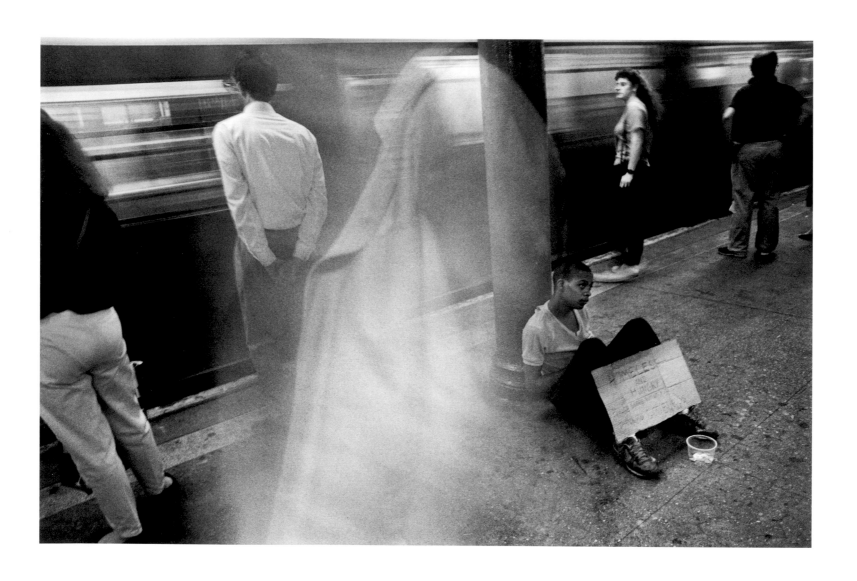

EUGENE RICHARDS BEGGAR ON THE SUBWAY, 1988

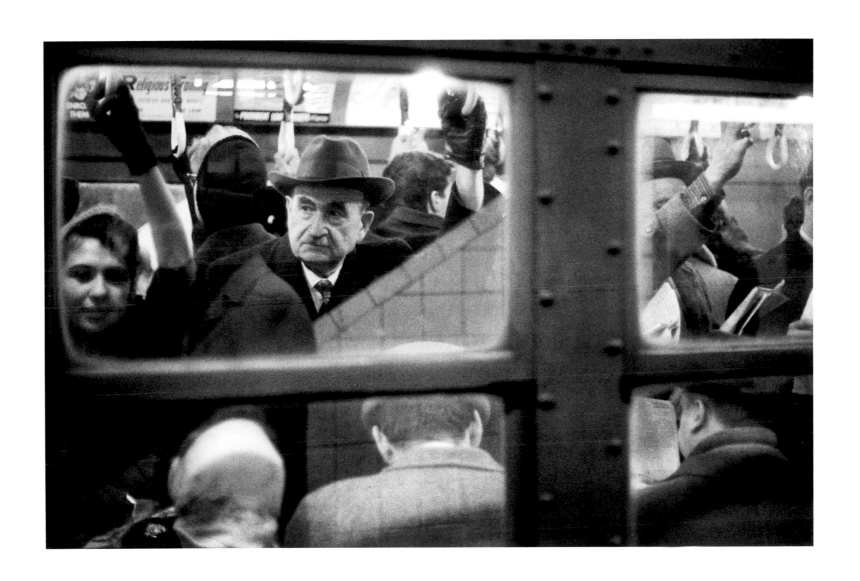

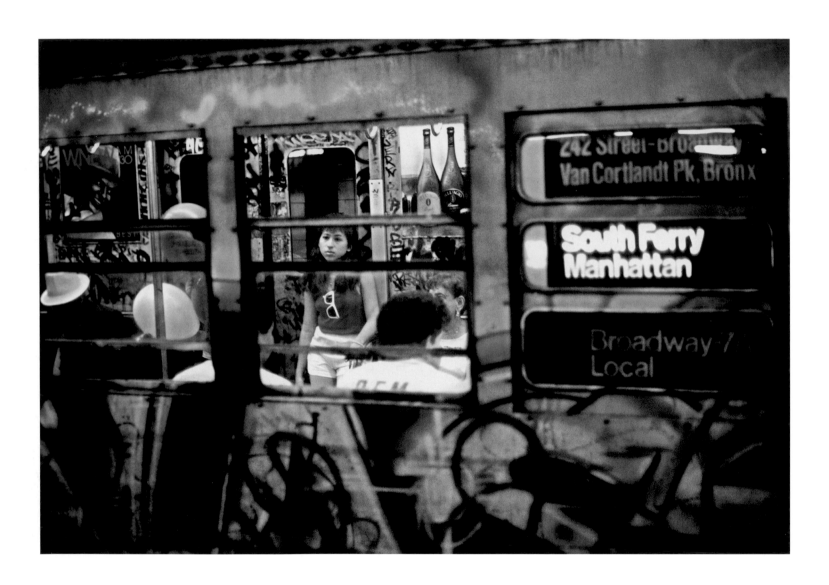

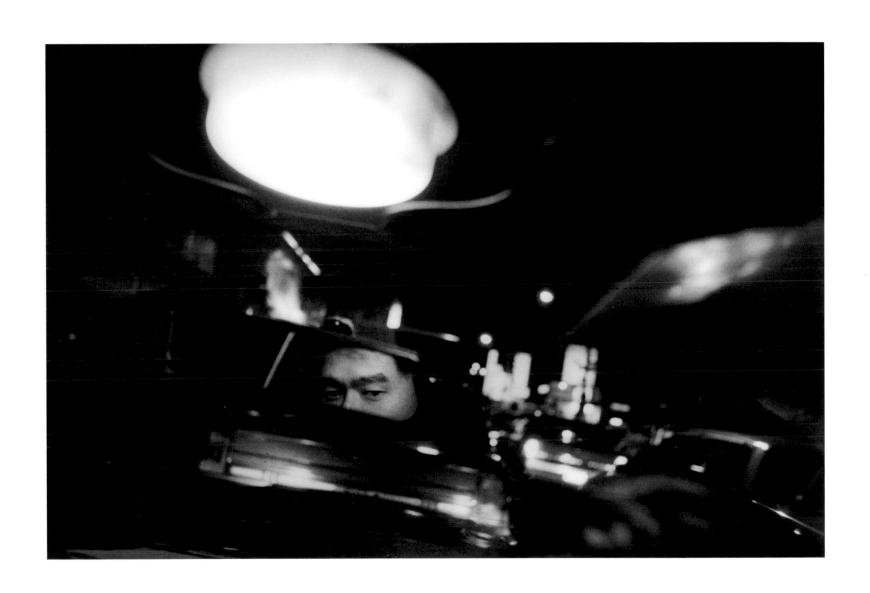

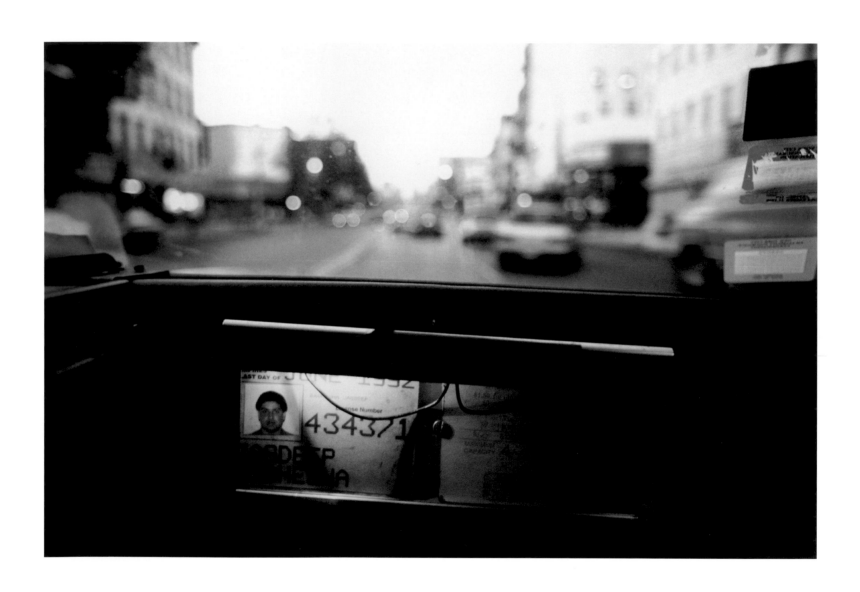

FERDINANDO SCIANNA INDIAN TAXI DRIVER'S CAB, 1985

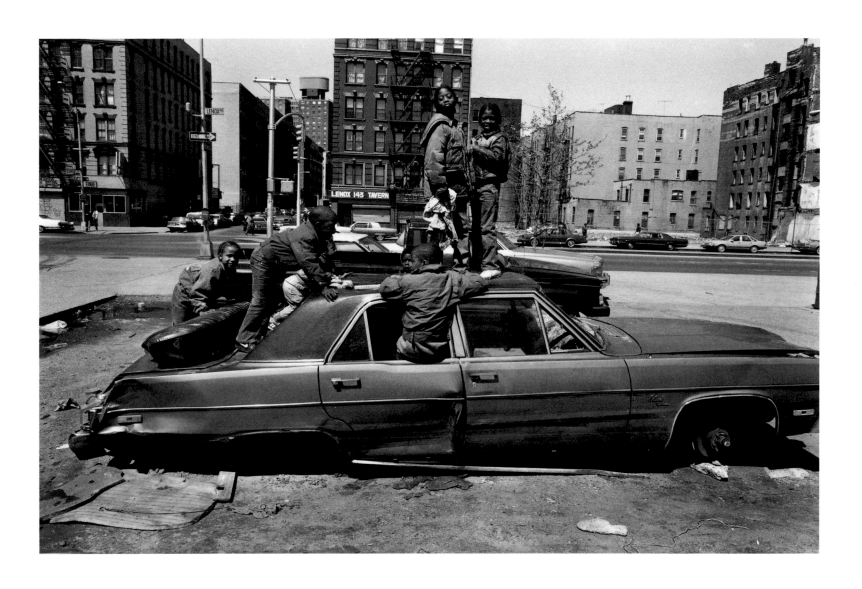

INTERIORS

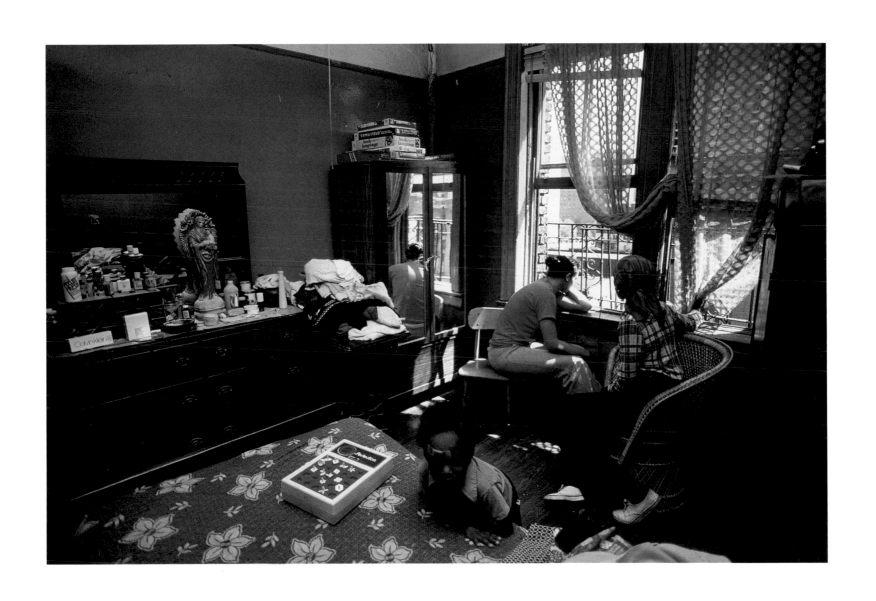

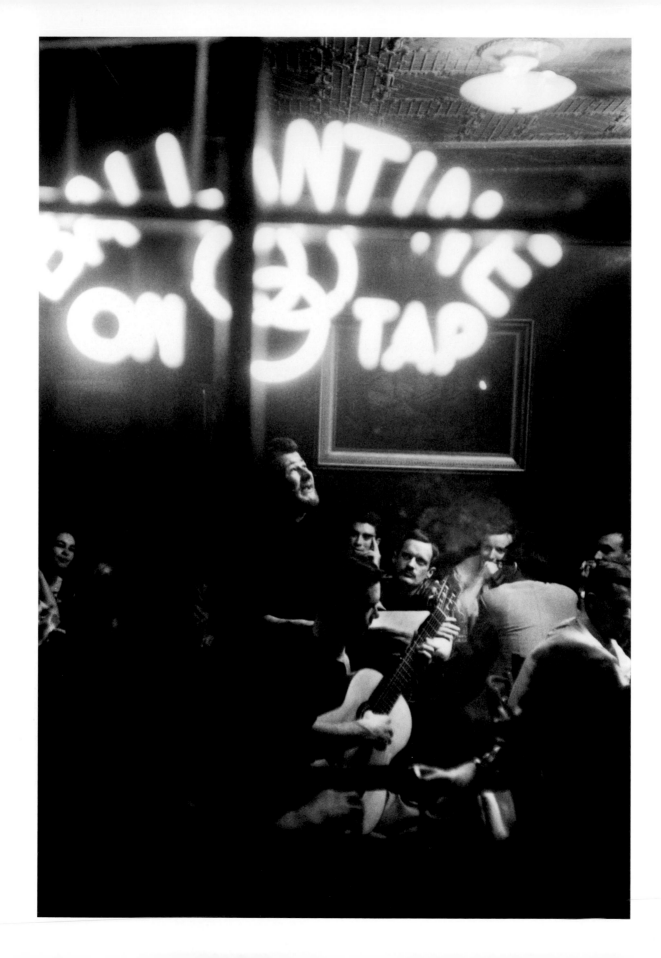

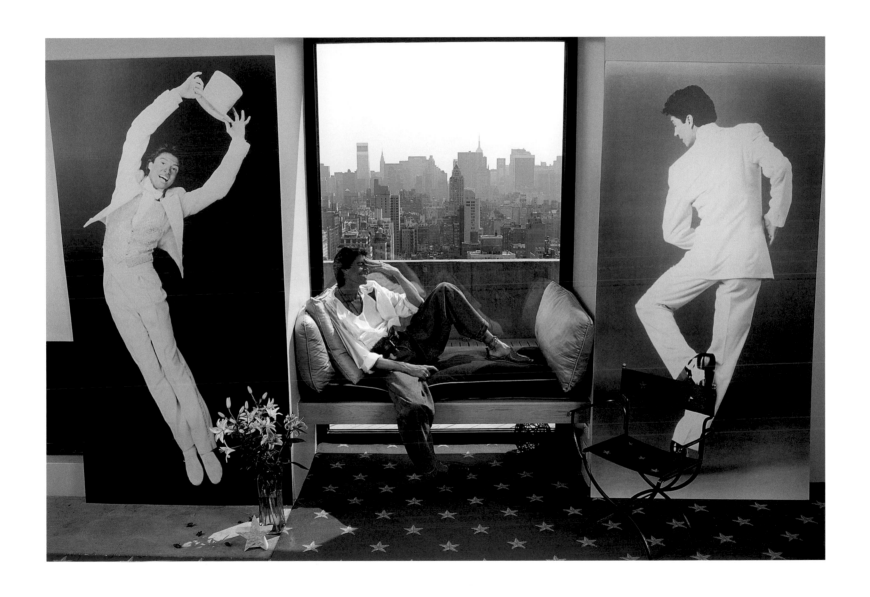

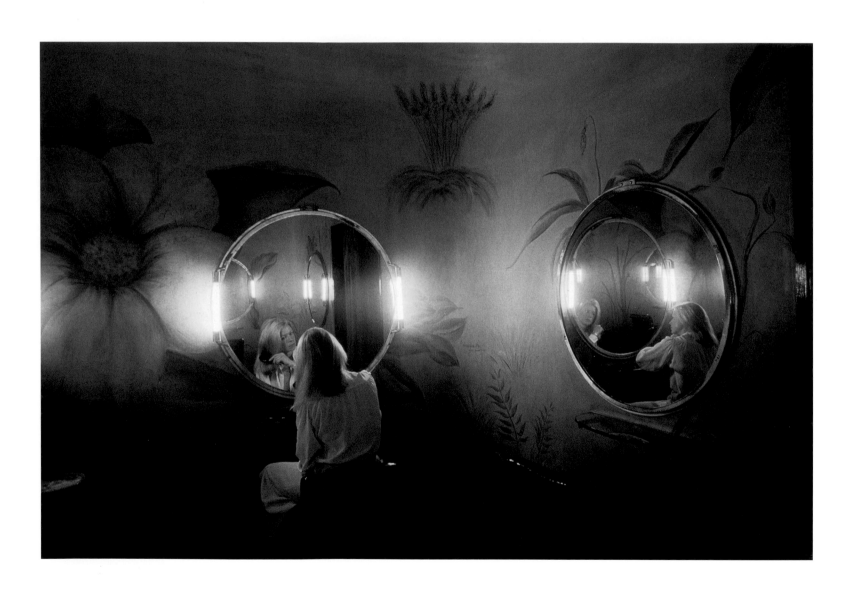

BURT GLINN THE LADIES LOUNGE IN THE SECOND MEZZANINE OF RADIO CITY MUSIC HALL, 1978

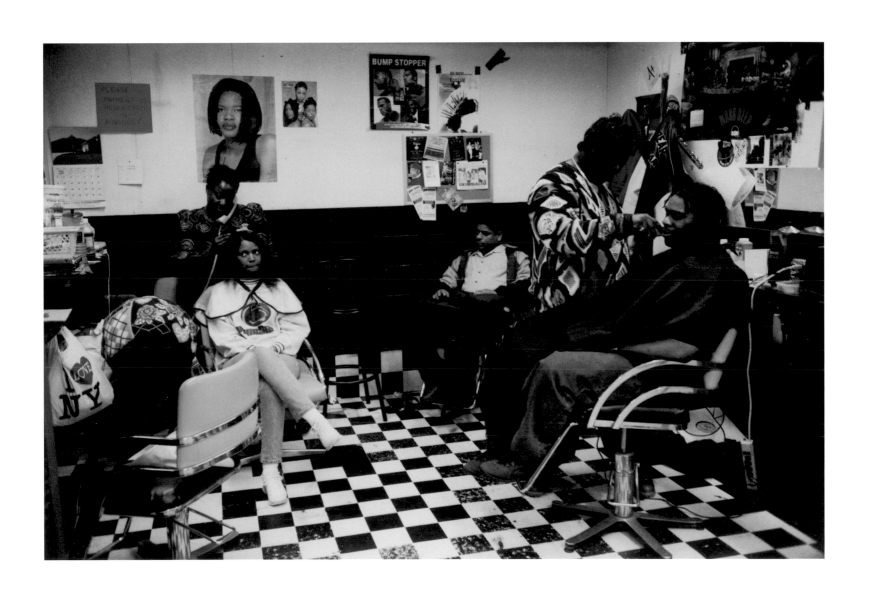

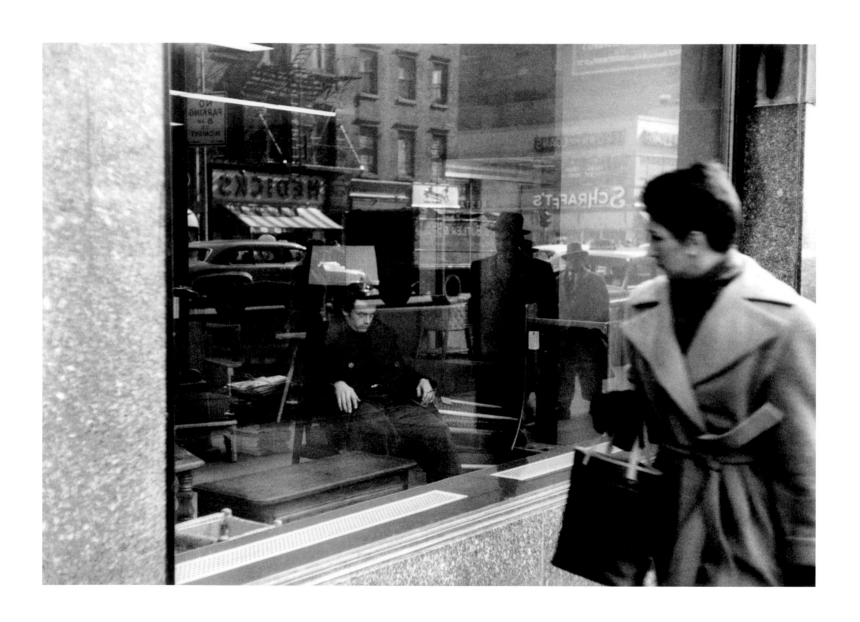

122 **DENNIS STOCK** JAMES DEAN POSING IN THE WINDOW OF A FURNITURE STORE NEAR ROCKEFELLER CENTER, 1955

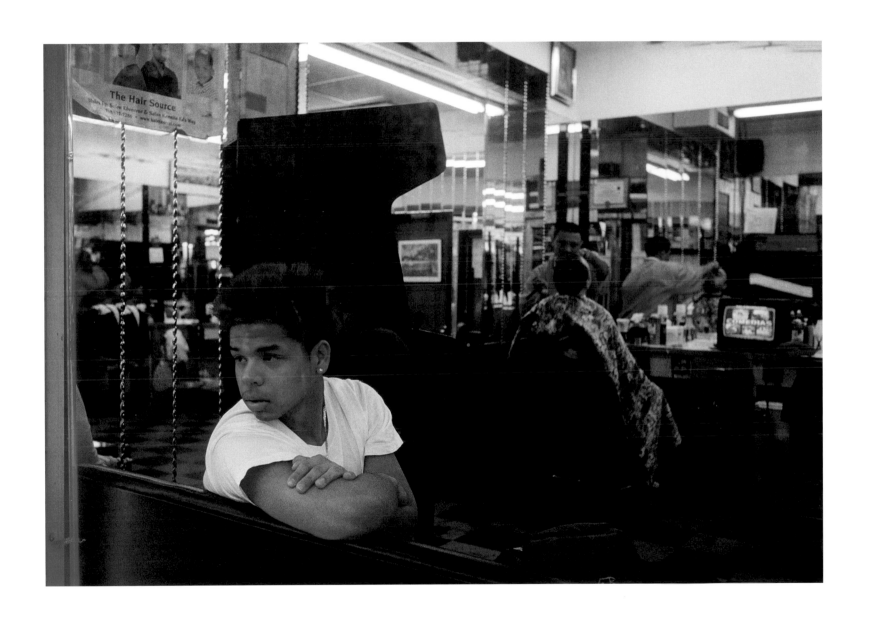

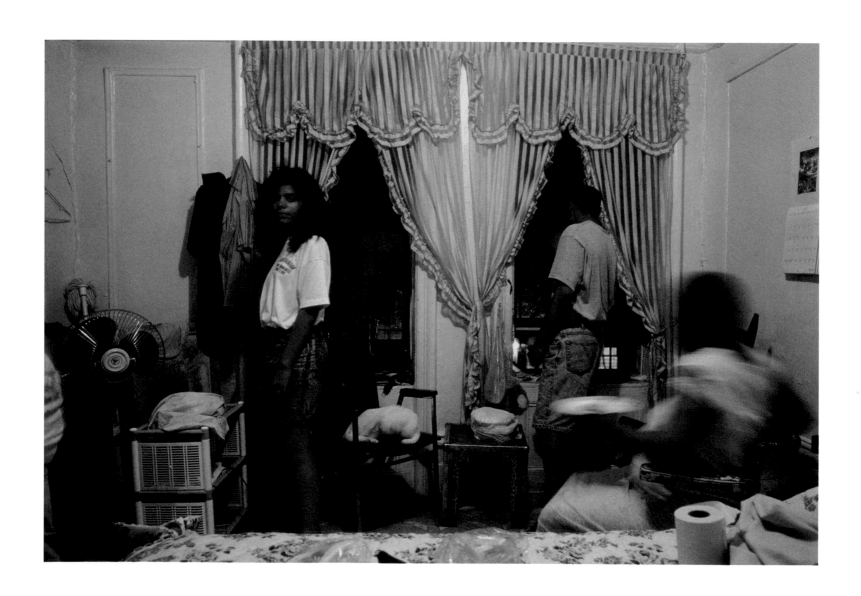

LISE SARFATI YOUNG LOVERS EDWARD AND ELVIRA IN THEIR APARTMENT IN BROOKLYN, 1995

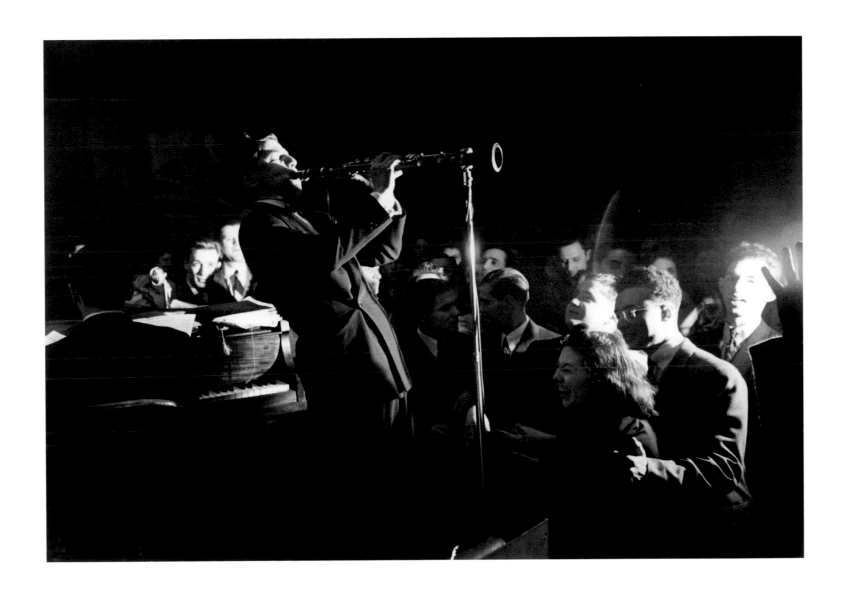

NEED TO TALK?

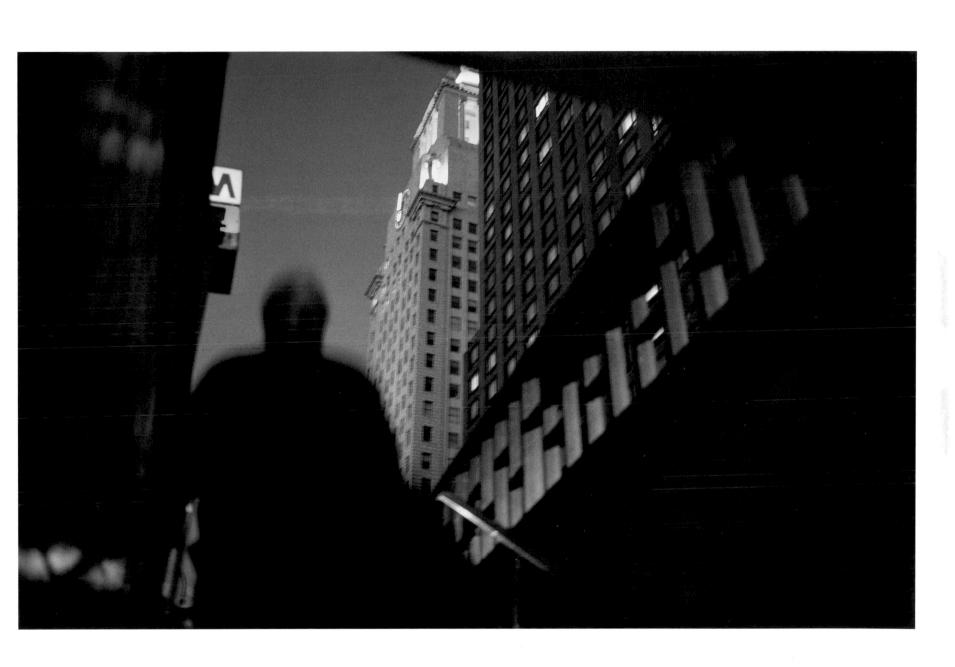

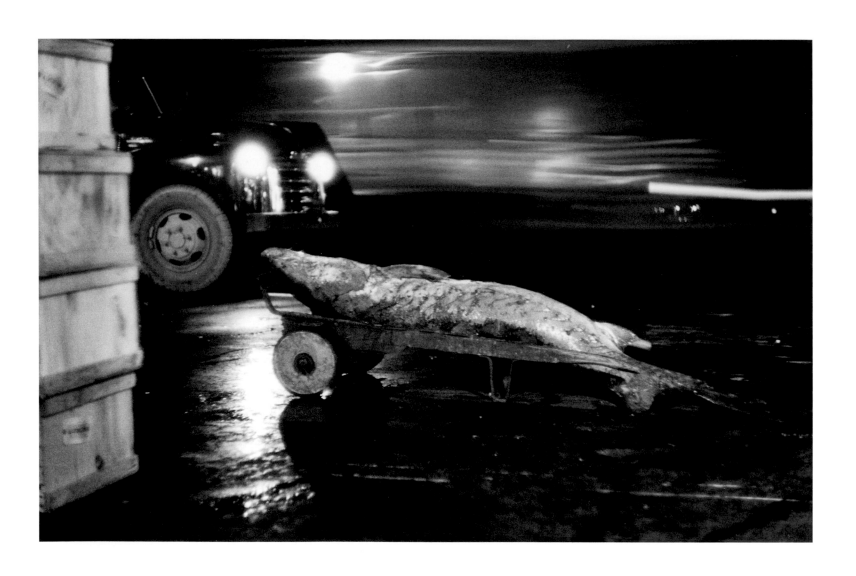

ELLIOTT ERWITT FULTON STREET FISH MARKET, 1953

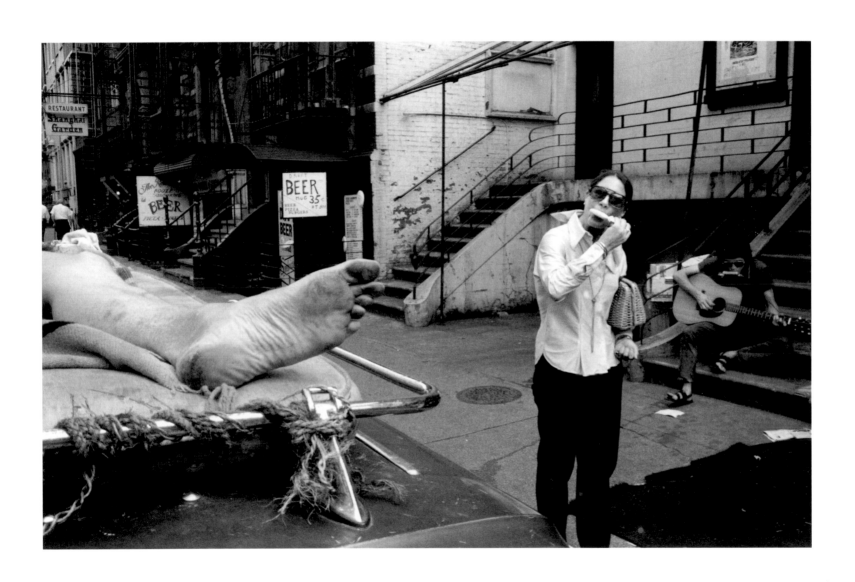

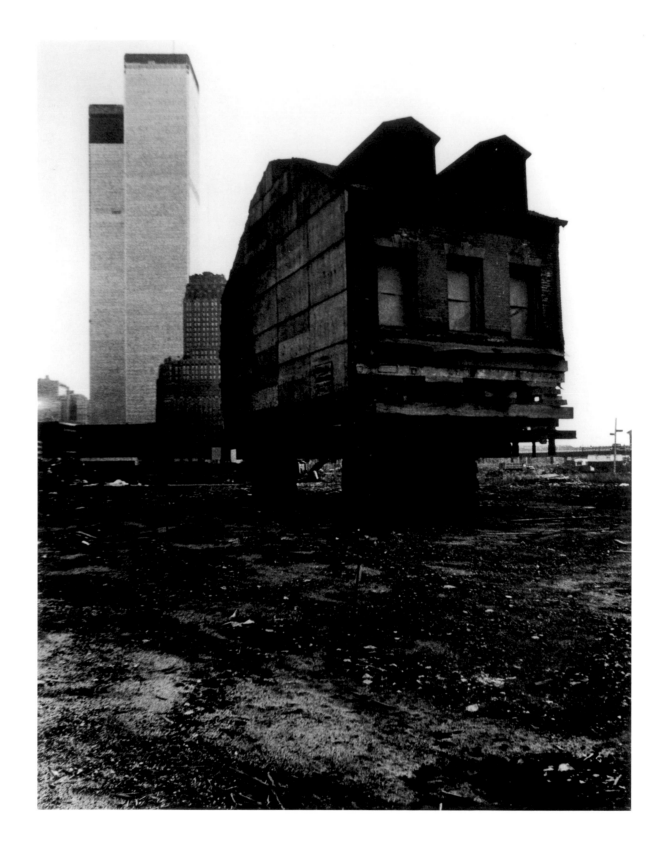

130 **MIGUEL RIO BRANCO** CLEARING OF LOWER MANHATTAN FOR THE CONSTRUCTION OF THE WORLD TRADE CENTER, 1971

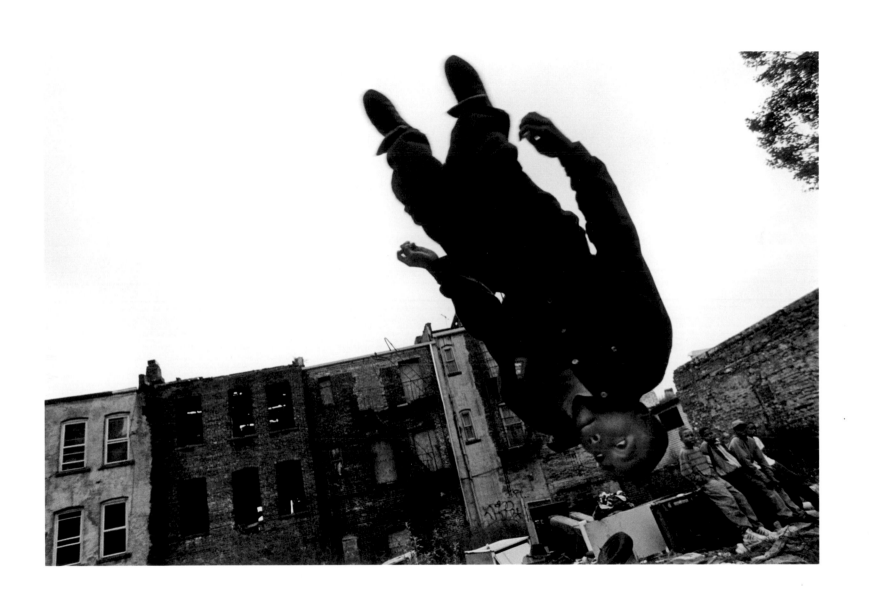

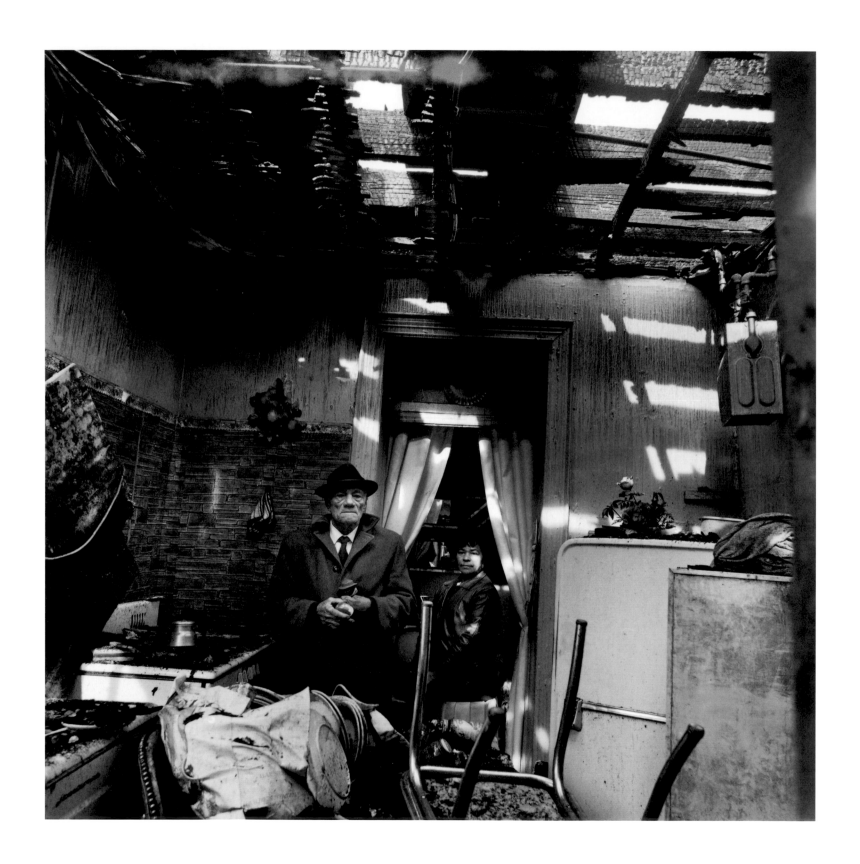

BRUCE DAVIDSON DERELICT BUILDING ON EAST 100TH STREET IN SPANISH HARLEM, 1966

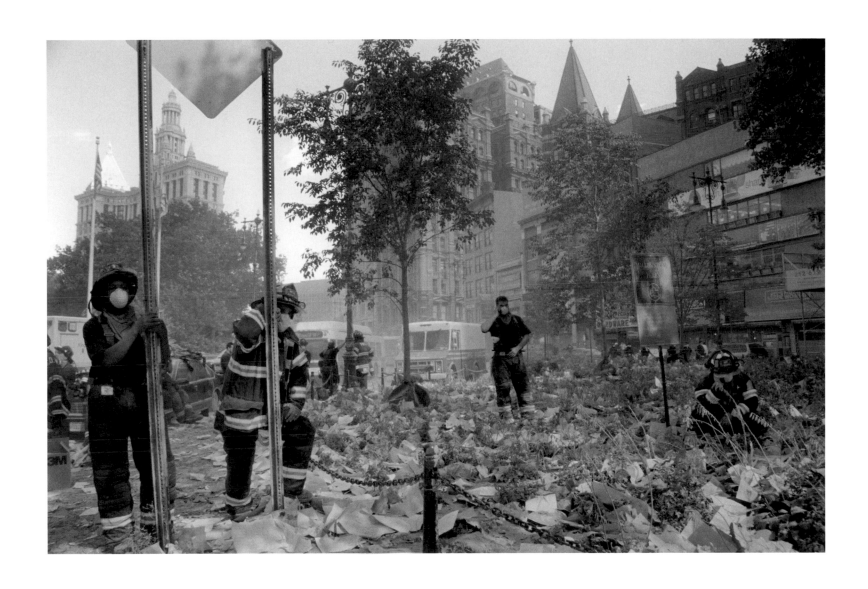

NEED TO TALK?

The events of September 11 have changed
our world. Do you need to talk...

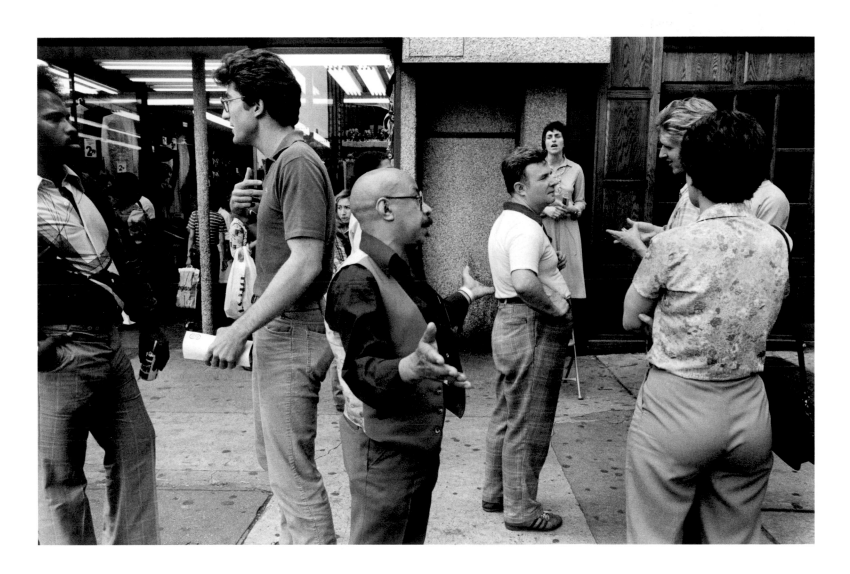

NOTABLES

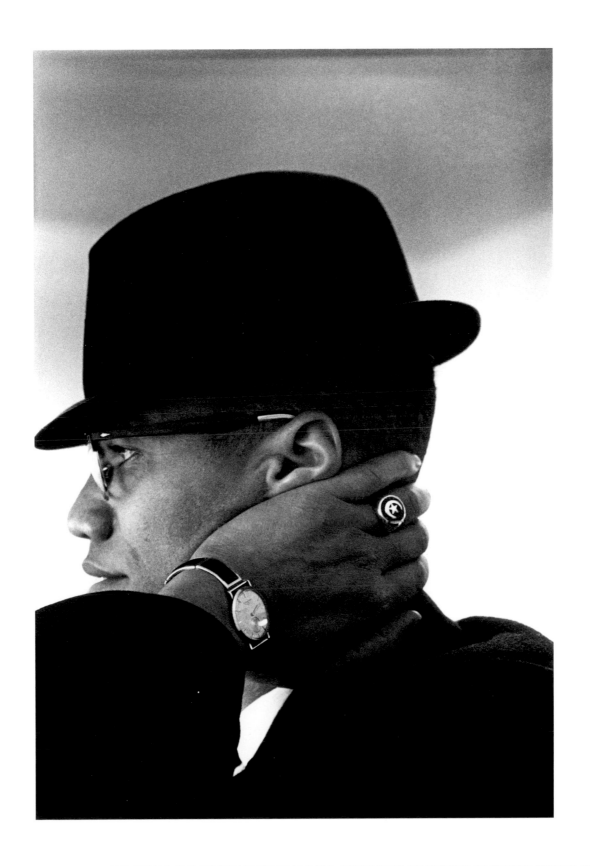

EVE ARNOLD CIVIL RIGHTS LEADER MALCOLM X, NATION OF ISLAM MINISTER OF MOSQUE NUMBER SEVEN IN HARLEM, 1961 137

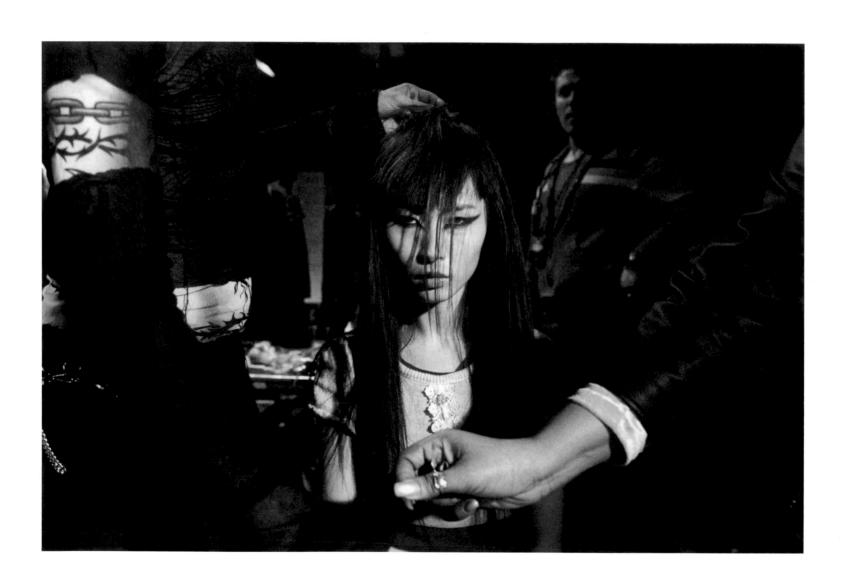

138 **FERDINANDO SCIANNA** MODEL AND HAIRDRESSER BACK STAGE AT A FASHION SHOW, 1997

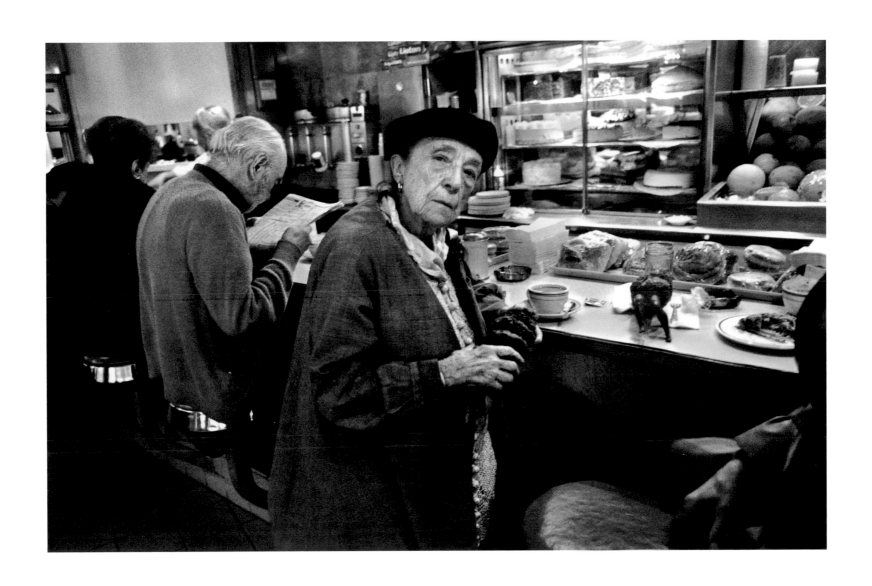

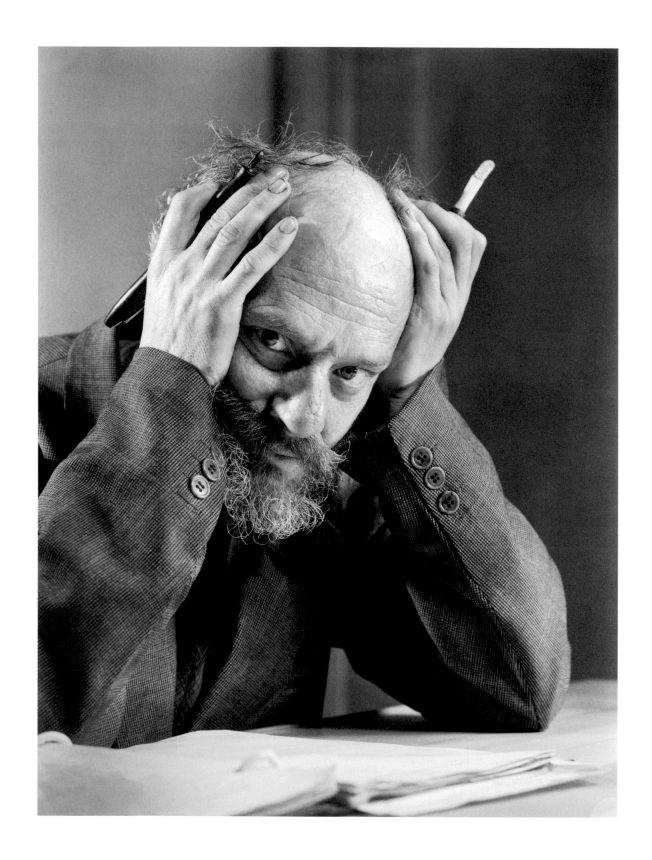

PHILIPPE HALSMAN GREENWICH VILLAGE BOHEMIAN JO GOULD, 1943

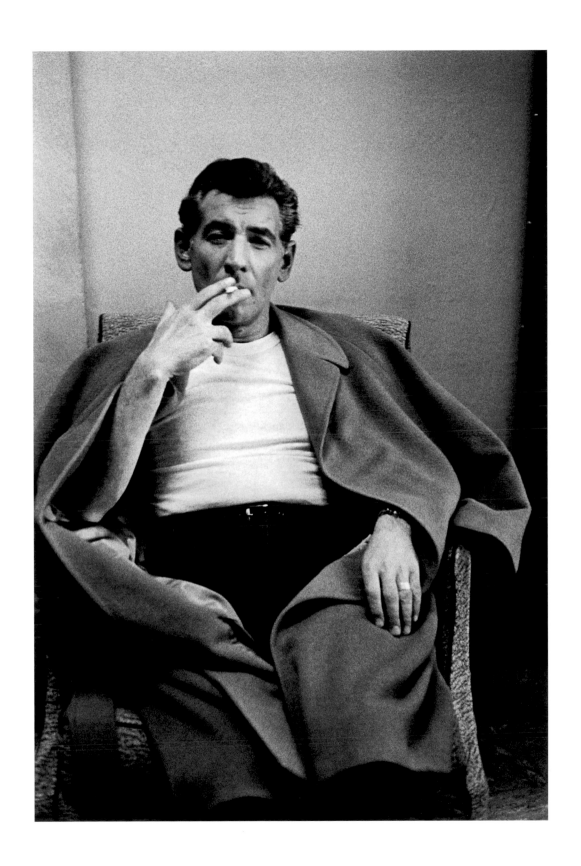

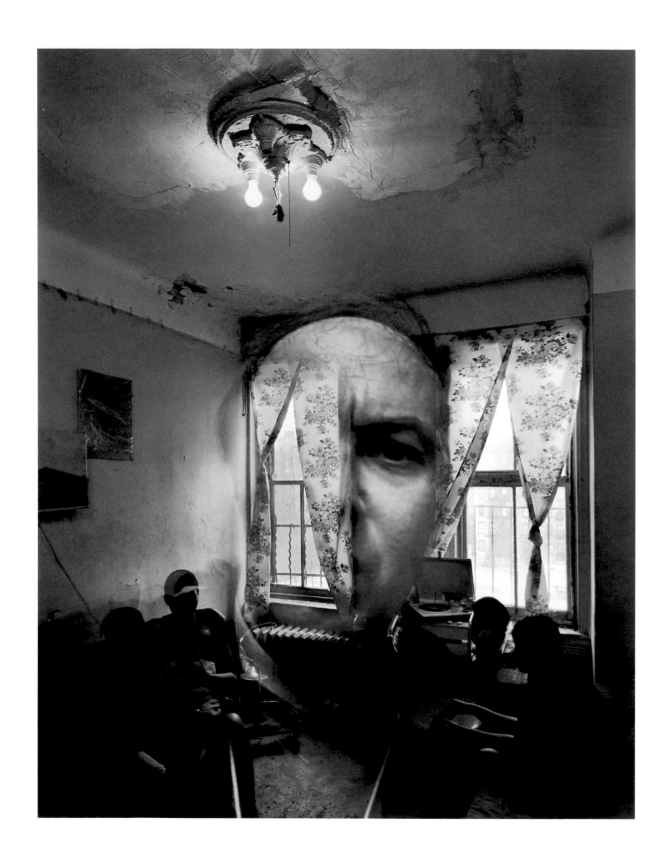

BRUCE DAVIDSON DOUBLE EXPOSURE, EAST 100TH STREET, 1966

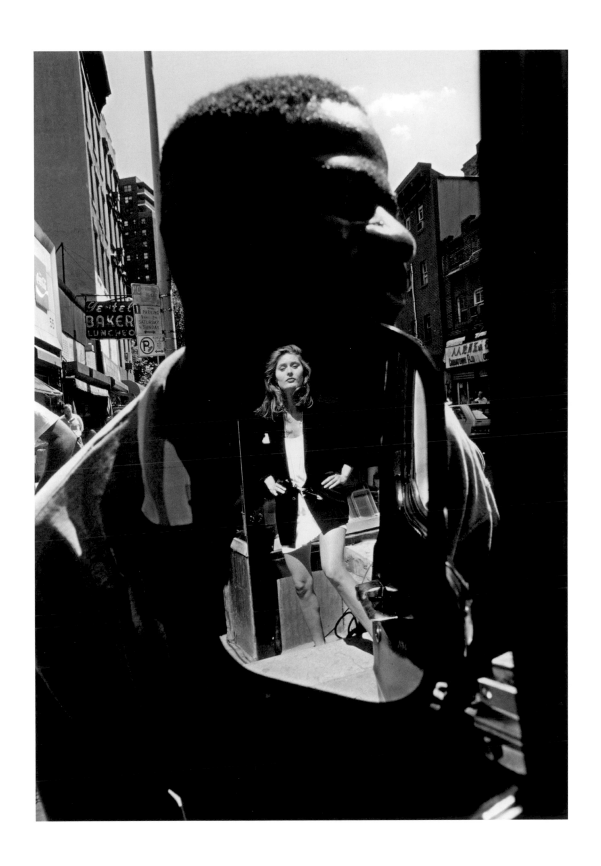

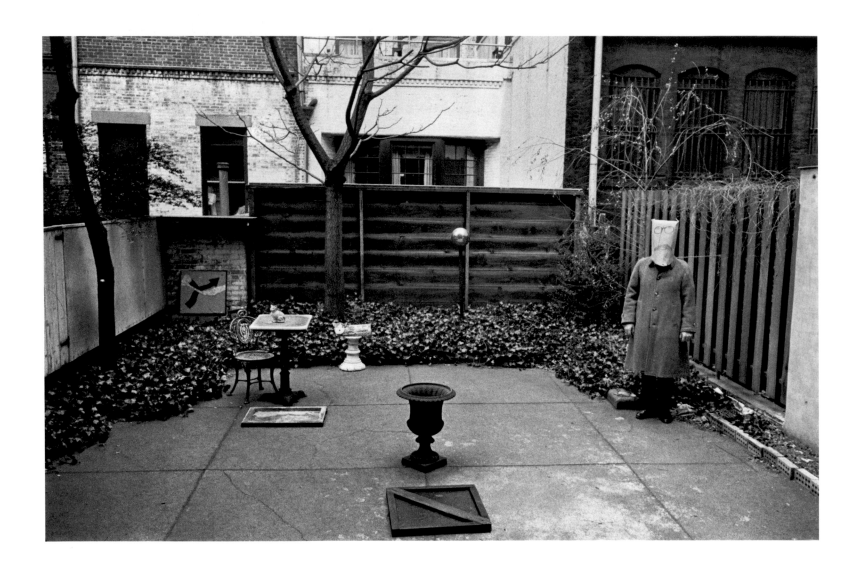

∧ **INGE MORATH** ILLUSTRATOR SAUL STEINBERG IN HIS GARDEN ON THE UPPER EAST SIDE, 1959 > **COSTA MANOS** TAXICAB DRIVERS, 1961

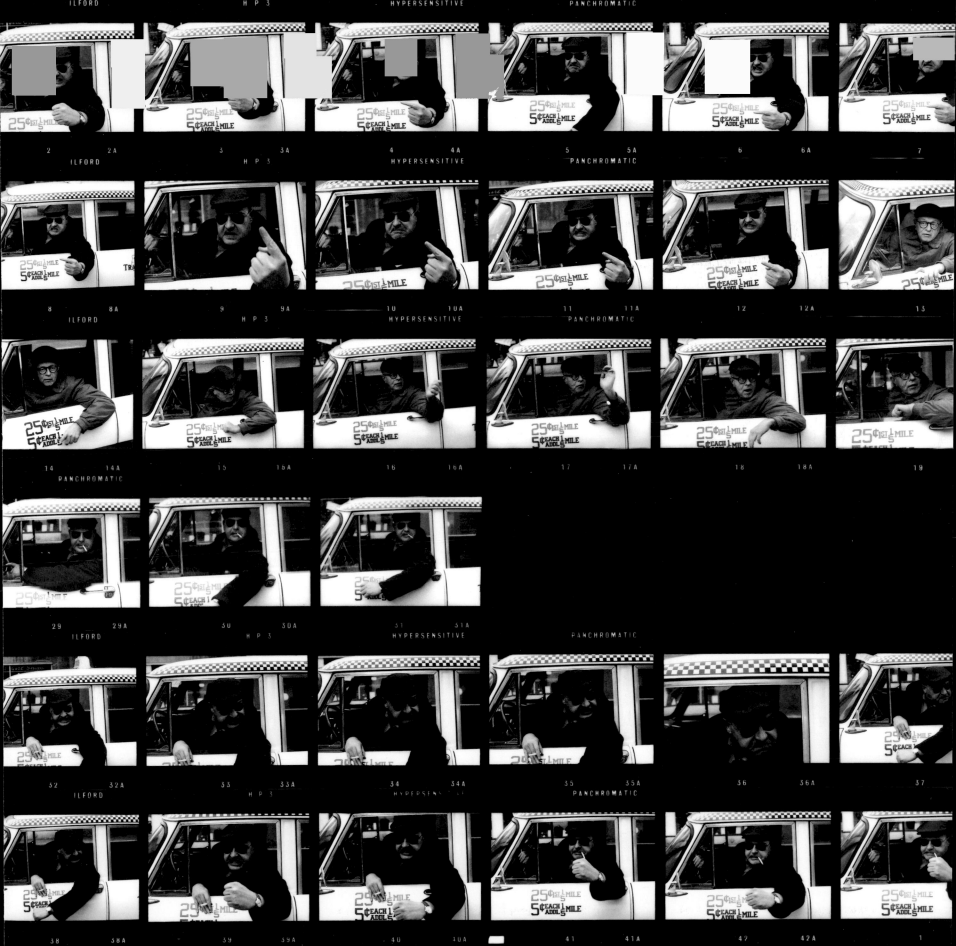

ELLIOTT ERWITT WRITER ARTHUR MILLER NEAR THE BROOKLYN BRIDGE, 1954

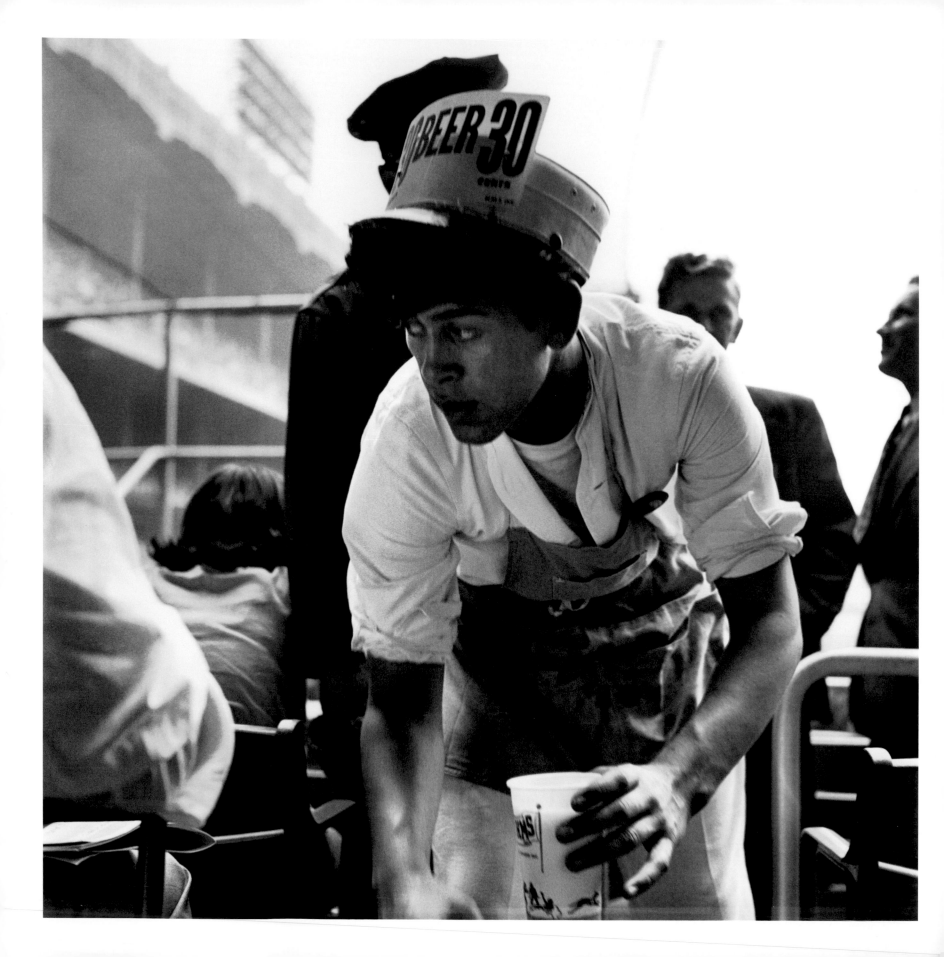

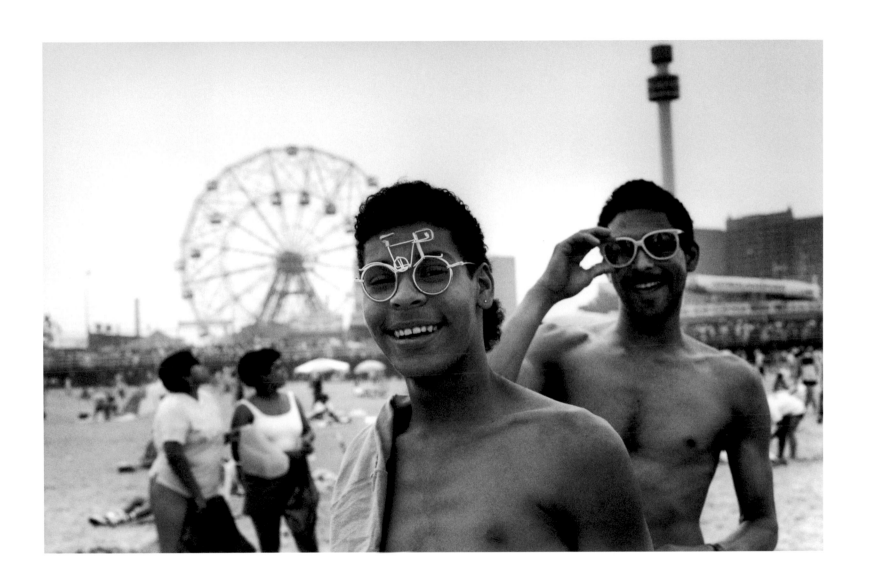

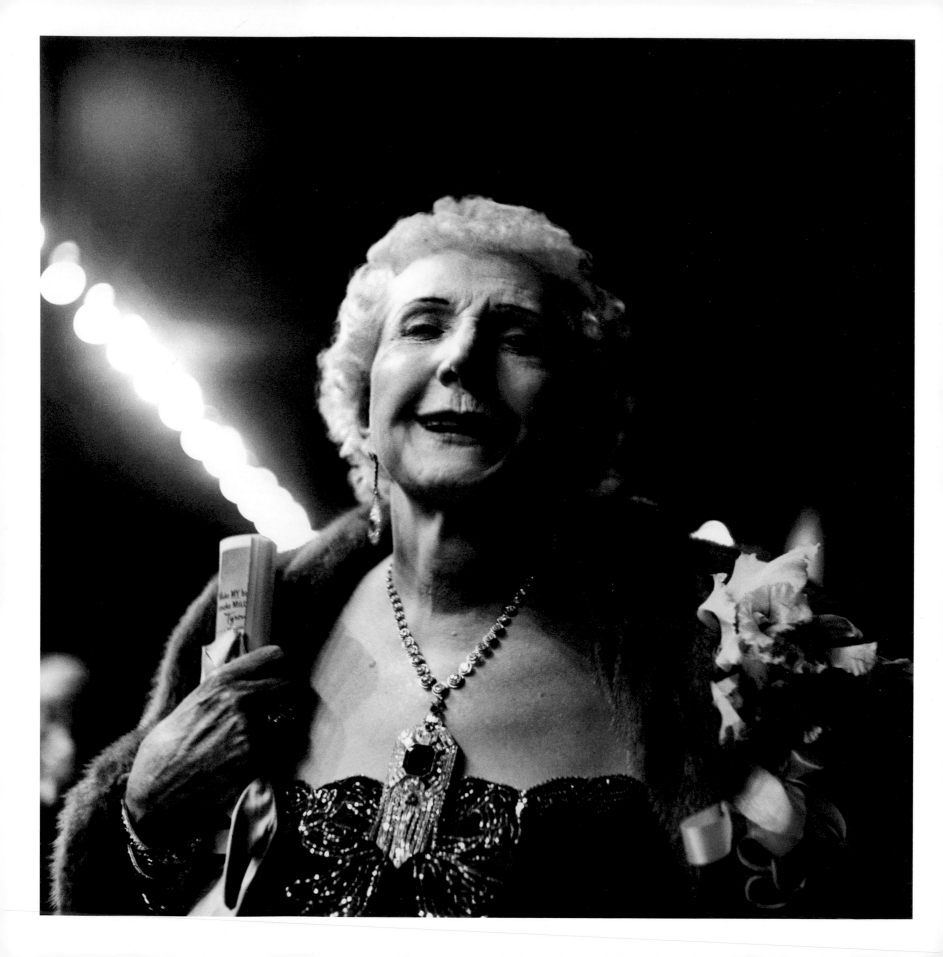

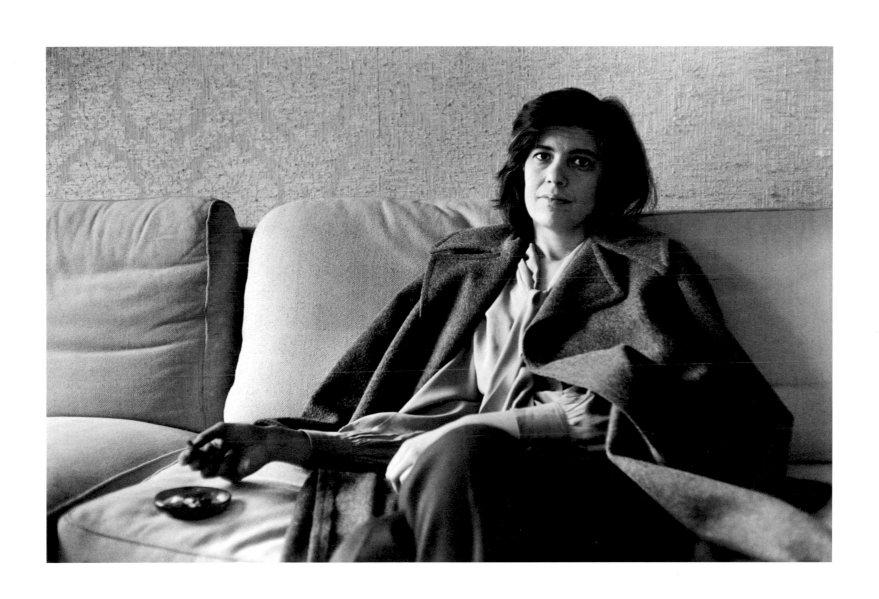

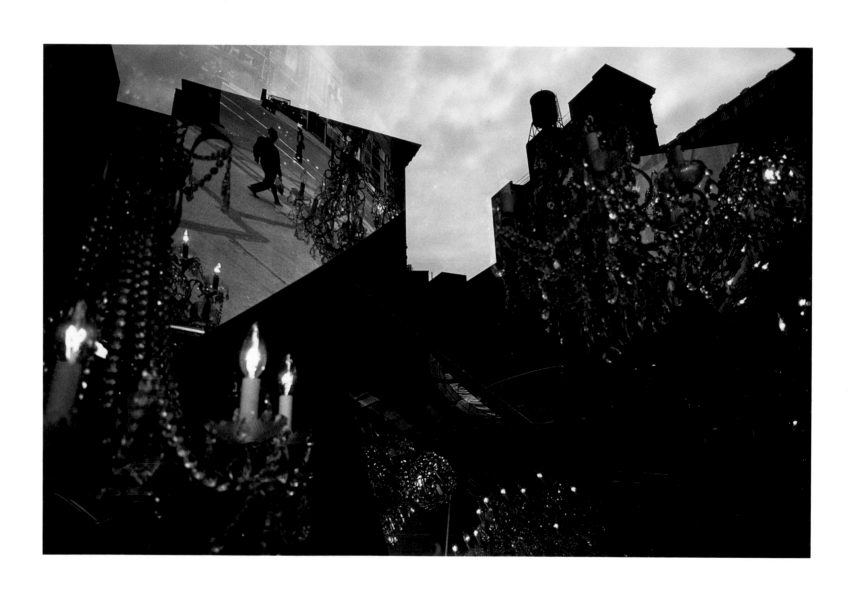

160 **RENE BURRI** SHOP WINDOW ON FIFTH AVENUE, 1977

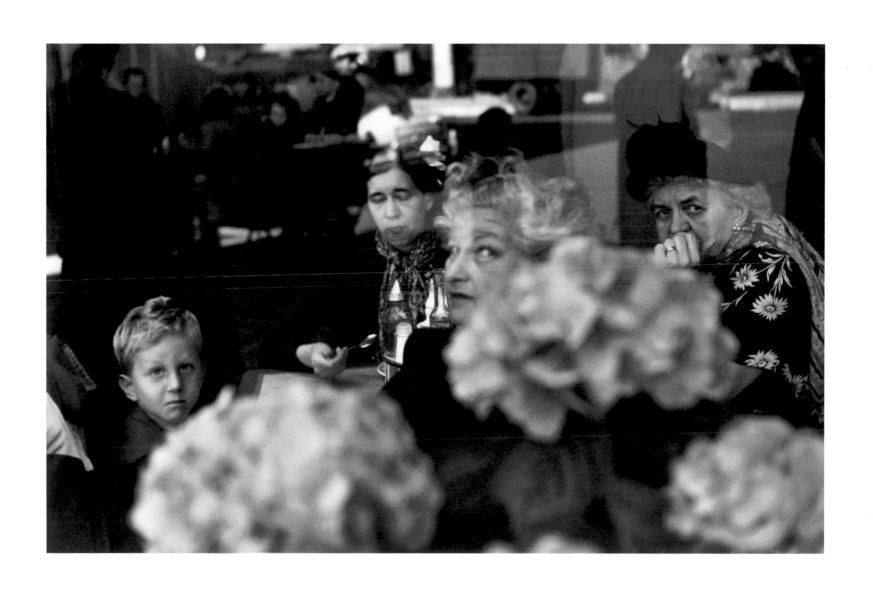

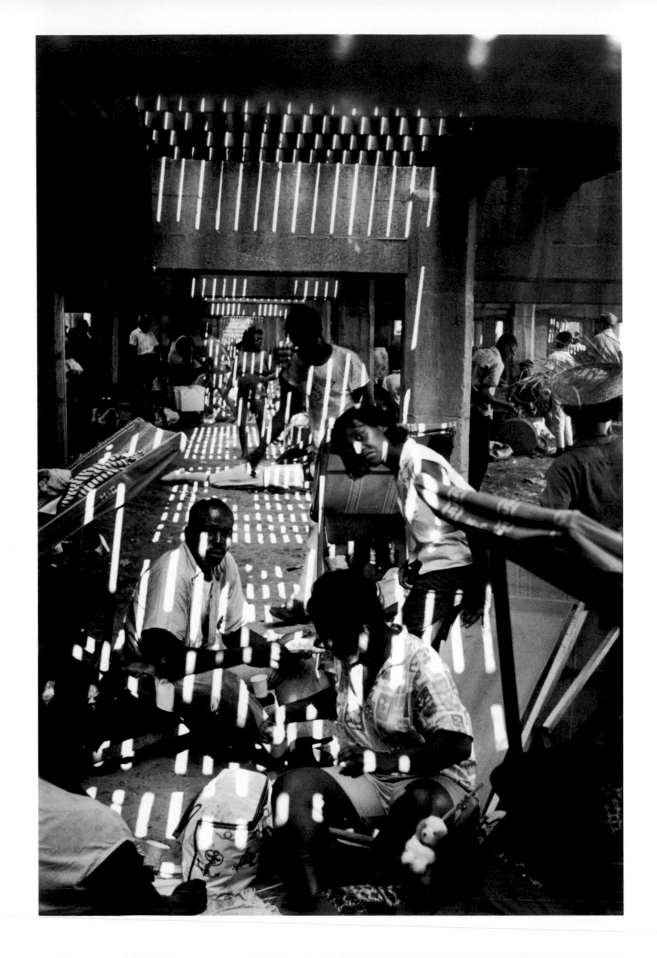

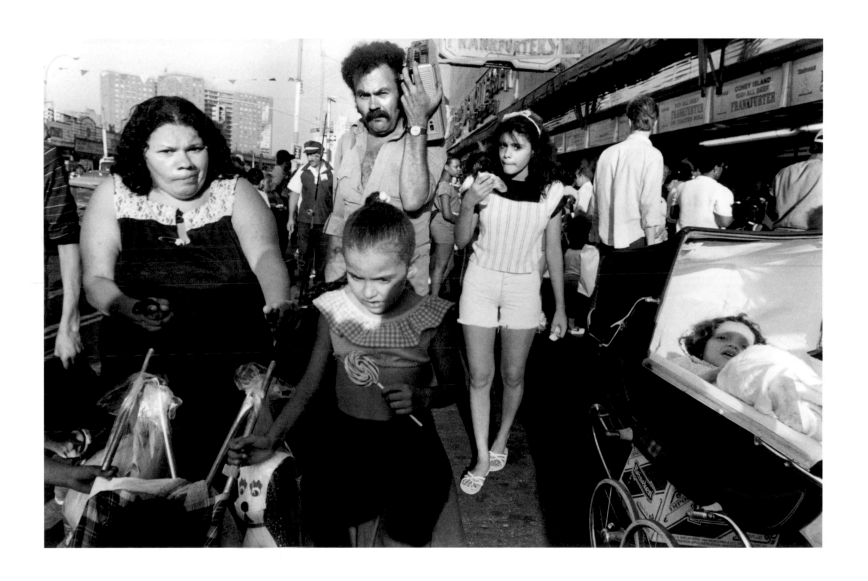

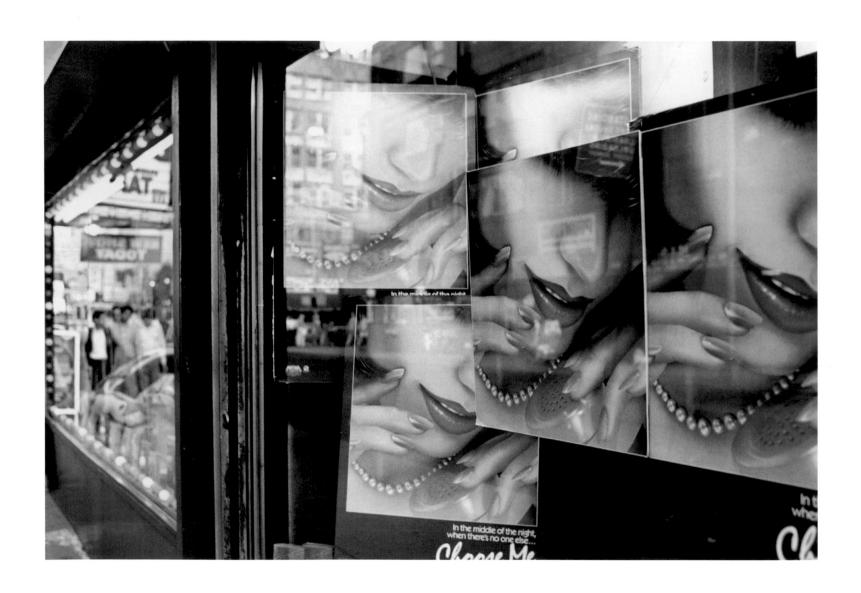

FERDINANDO SCIANNA ADVERTISING WINDOW DISPLAY IN MIDTOWN, 1985

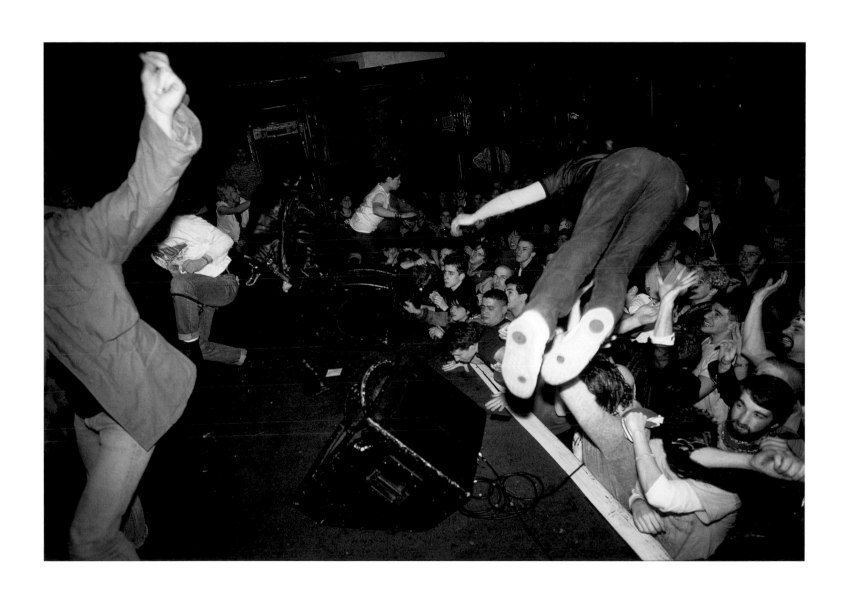

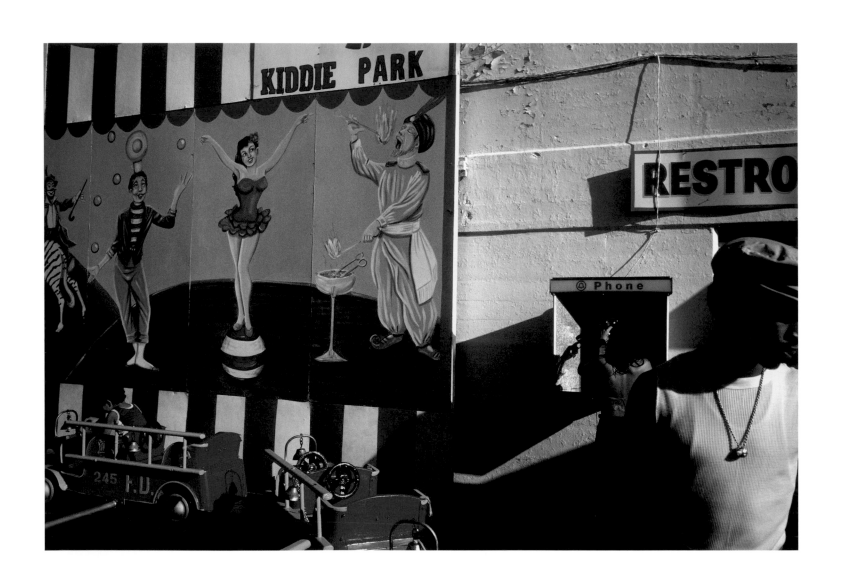

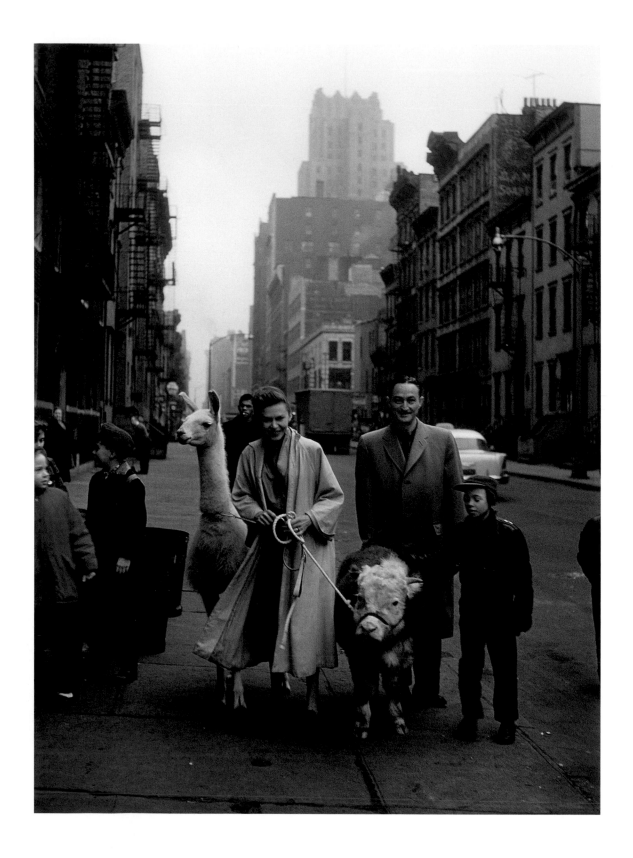

168 **INGE MORATH** BARNUM & BAILEY'S CIRCUS ANIMALS IN MIDTOWN MANHATTAN, 1957

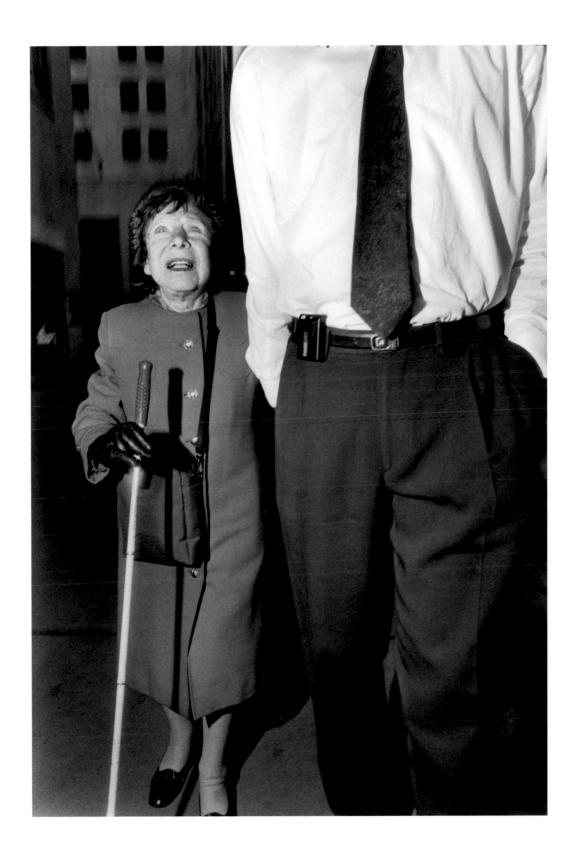

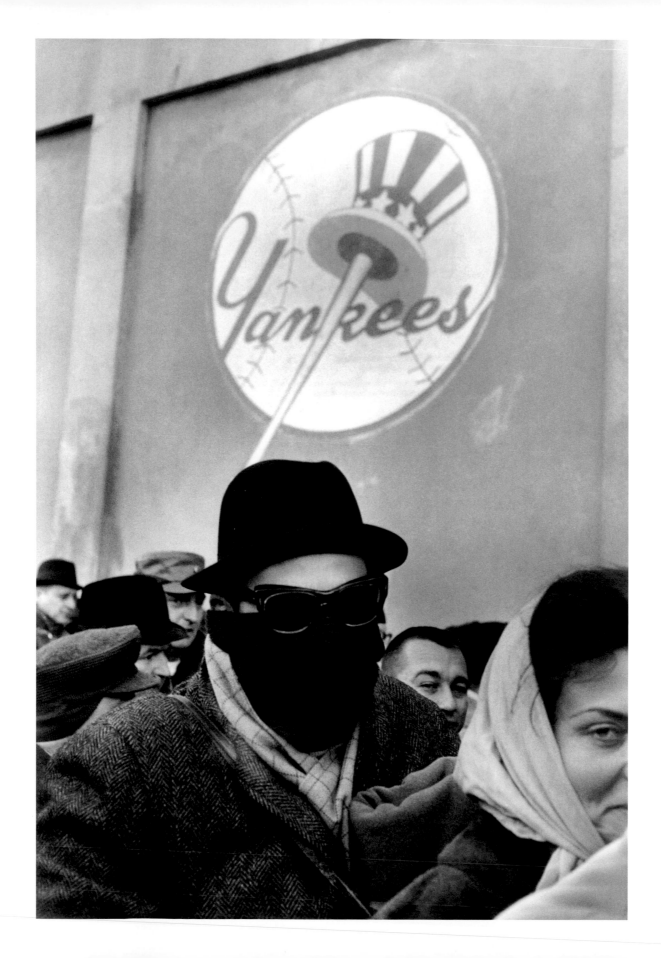

< **HENRI CARTIER-BRESSON** YANKEE STADIUM IN THE BRONX, 1962 ^ **BRUCE DAVIDSON** FRUIT CART ON THE LOWER EAST SIDE, 1968 171

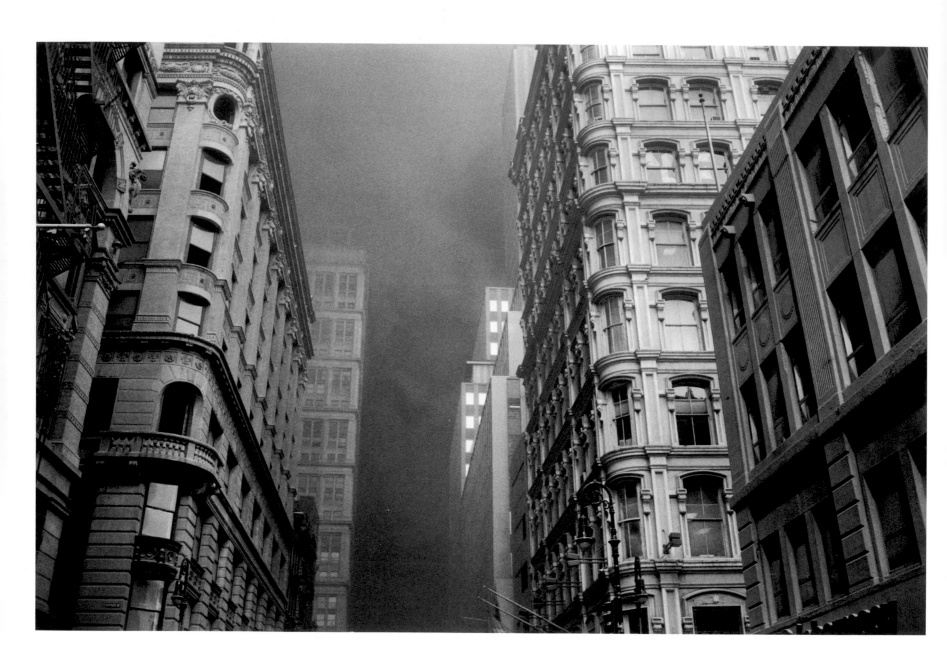

172 ∧ **LARRY TOWELL** CLOUDS OF SMOKE AND DEBRIS FROM THE COLLAPSE OF THE WORLD TRADE CENTER, 2001 > **ERICH HARTMANN** BROADWAY, 1971

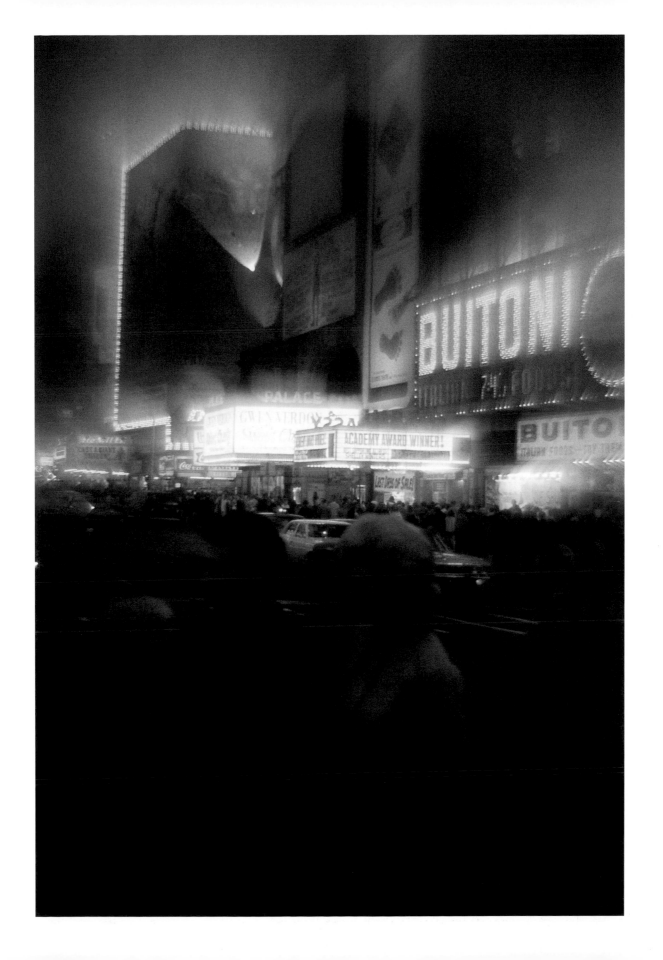

173

ALEX MAJOLI HAILING A CAB IN A SNOW STORM, 2003

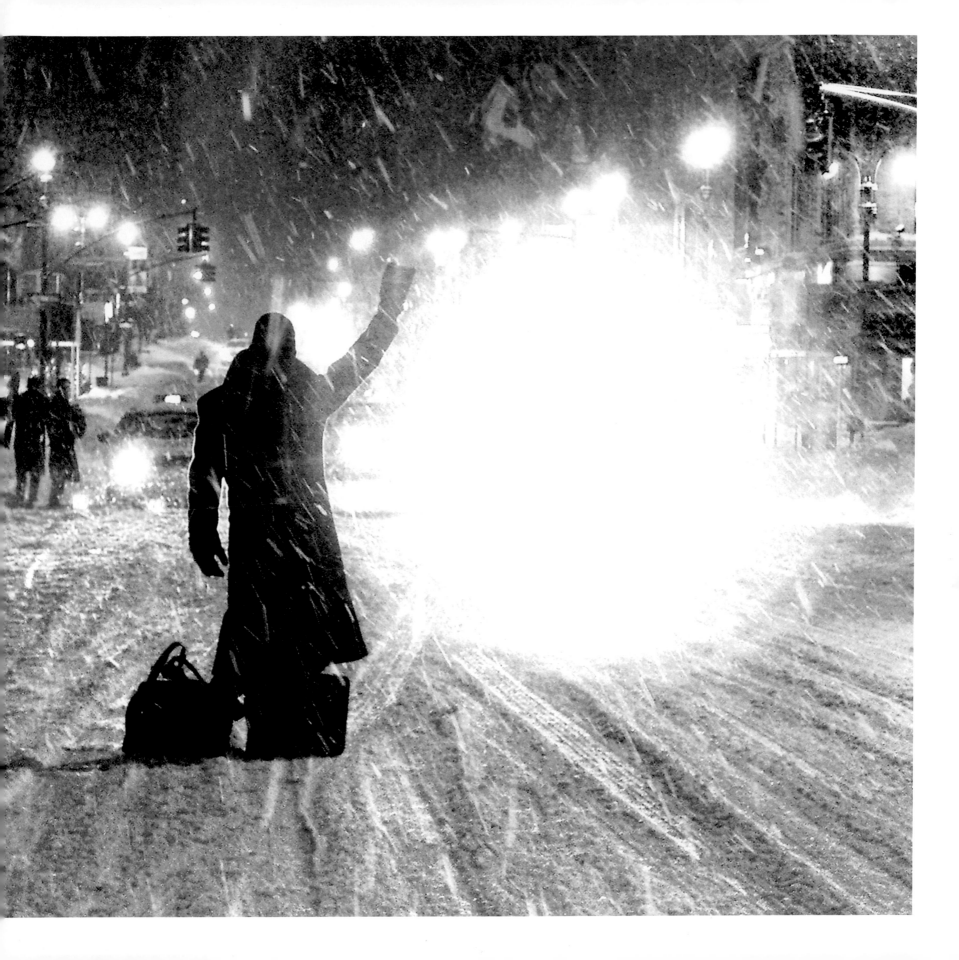

NEW YORKERS
AS SEEN BY MAGNUM PHOTOGRAPHERS

Published in the United States by powerHouse Books,
a division of powerHouse Cultural Entertainment, Inc.
68 Charlton Street, New York, NY 10014-4601
telephone 212 604 9074, fax 212 366 5247
e-mail: newyorkers@powerHouseBooks.com
web site: www.powerHouseBooks.com

First edition, 2003

Library of Congress Cataloging-in-Publication Data:

New Yorkers : as seen by Magnum photographers / photographs by Magnum
photographers ; editing and introduction by Max Kozloff.-- 1st ed.
 p. cm.
 ISBN 1-57687-185-1
 1. Portrait photography--New York (State)--New York. I. Kozloff, Max.
II. Magnum Photos, inc.
 TR680 .N455 2003
 779'.2'097471--dc21

 2003011189

Hardcover ISBN 1-57687-185-1

Associate Book Designer: Kristi Norgaard
Separations, printing, and binding by EBS, Verona

A complete catalog of powerHouse Books and
Limited Editions is available upon request;
please call, write, or visit New York on our web site.

10 9 8 7 6 5 4 3 2 1

Printed and bound in Italy

BOOK DESIGN BY YOLANDA CUOMO, NYC

For his enthusiastic provision of technical aid and knowledgeable introduction to a vast archive, I owe David Strettell, Director of Cultural Projects at Magnum, the warmest thanks. He serenely monitored a process that was logistically complicated, and that was tense with deadlines. Nathalie Santini in the Paris office and Kim Bourus in the New York office gave sympathetic help. I appreciate also the good graces of Eelco Wolf and James Danziger, who offered moral support without my asking. At powerHouse Books, Meg Handler and Craig Cohen made my work much easier than I expected. For Yolanda Cuomo's expert design of the book, I'm most grateful. And to the photographers, who had to respond to my unpredictable ways, but who, in end, were very gracious, I tip my hat. —Max Kozloff